RANCH STYLE

The Artistic Culture and Design of the Real West

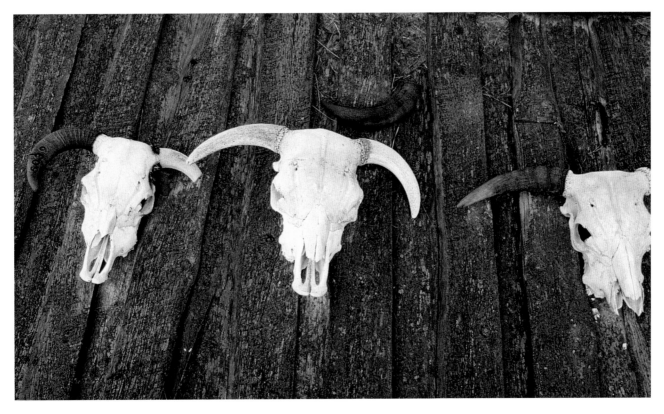

Bar 13 Ranch
Mackay, Idaho

Photography by David R. Stoecklein

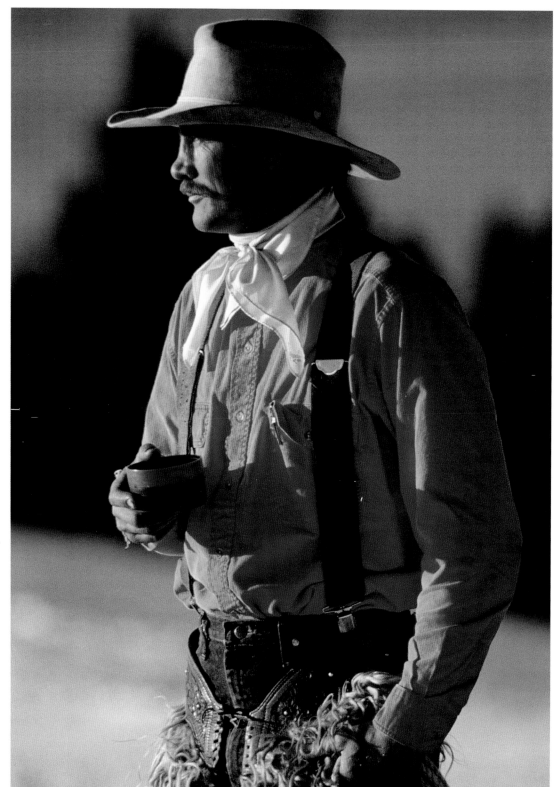

Jack Goddard
Mackay, Idaho

This book is for my friend,

Jack Goddard, who taught me

so much about the West.

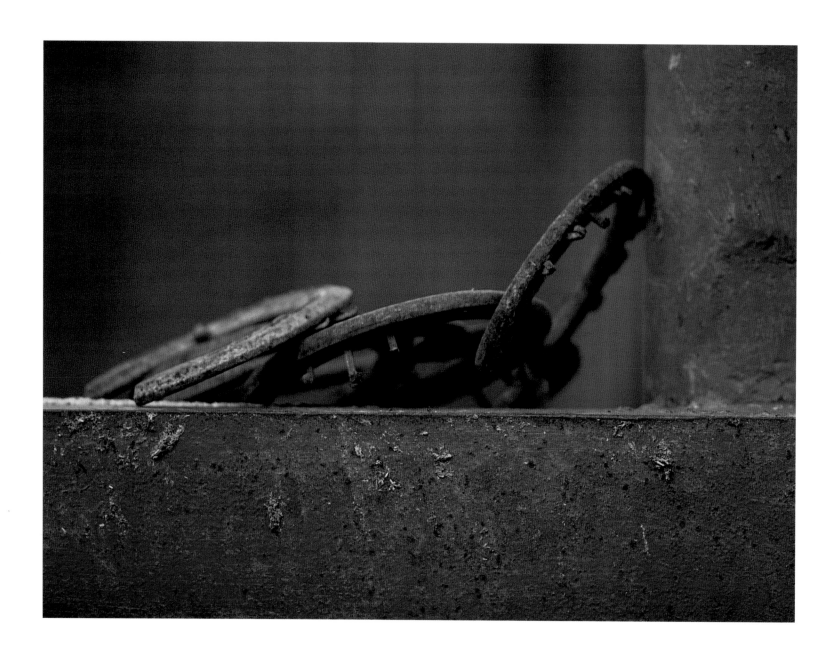

Horseshoes, Twin V Ranch
Weatherford, Texas

RANCH STYLE

The Artistic Culture and Design of the Real West

PHOTOGRAPHY DAVID R. STOECKLEIN

EDITOR CARRIE JAMES

ART DIRECTION & DESIGN T-GRAPHICS

Cover Photo - *Three Sisters Ranch, Mackay, Idaho*
Back Cover Photo - *Bar 13 Ranch, Mackay, Idaho*

All images in this book are available as signed original gallery prints and for stock photography usage. Stoecklein Photography houses an extensive stock library of Western, sports, and lifestyle images. Dave Stoecklein is also an assignment photographer whose clients include Canon, Kodak, Bayer, Hatteras, Marlboro, Chevrolet, Timberland, Ford, Wrangler, Pontiac, and the Cayman Islands.

Other books by Stoecklein Publishing include *The Idaho Cowboy, Cowboy Gear, Don't Fence Me In, The Texas Cowboys, The Montana Cowboy, The Western Horse, Cowgirls, Spirit of the West, The California Cowboy, The Performance Horse, Cow Dogs, Lil' Buckaroos,* and *The American Paint Horse.*

Every year, Stoecklein Publishing also produces a line of wall calendars, prints, and cards featuring the
Western photography of David R. Stoecklein.
For more information or to request a catalog, please contact:

Stoecklein Publishing & Photography
Tenth Street Center, Suite A1
Post Office Box 856 • Ketchum, Idaho 83340
tel 208.726.5191 fax 208.726.9752 toll-free 800.727.5191
www.stoeckleinphotography.com

Printed in China

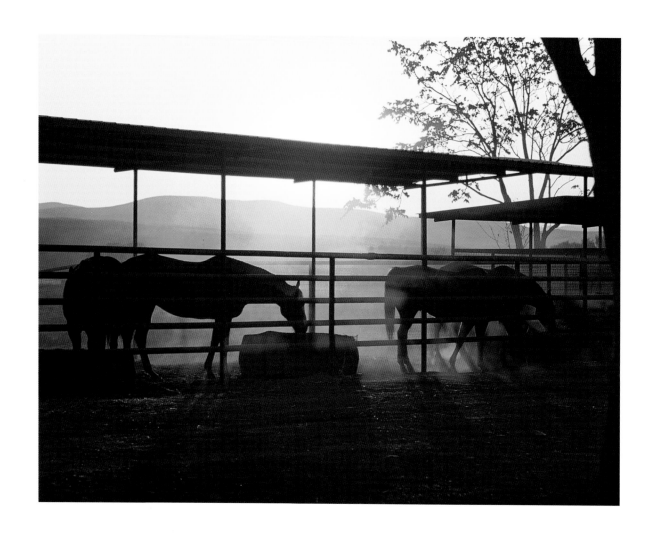

Jack Ranch
Paso Robles, California

Introduction

This is a book of photographs depicting the order and design of everyday things on the ranches that I have been visiting for the last fifteen years. The importance of placement is paramount on a ranch. It is evident in how a fence is built, what materials are used to build it, and where the gates are placed. The overhead ranch gates that frame the landscape open up to magnificent vistas and the roads lead your eyes to a perfect view of the ranch.

Barns are always an essential part of the composition or layout of a ranch. They are placed as an artist would place them in a painting, often to provide shade or shelter from the wind, and they become part of the overall design of a ranch. Ranch brands, a proud mark of ownership, are painted on the sides of many barns. Items such as saddles and branding irons are stored or proudly displayed in barns with an order and precision as if an interior decorator had arranged them. Ranch houses, bunkhouses, grain sheds, and workshops are always covered with brands and tools of the West. Cowhides, skulls, deer and elk antlers adorn gates and walls both inside and out. Old signs and battered license plates are tacked up everywhere. It may seem as if it is all haphazard and random; however, there is a special style to it. Wagons are lined up just so to set off the beauty of a pasture or to serve as the foreground in a view of an old oak tree. Owners use old wagon wheels as gates or fences or as part of the design of a barn wall. Gate latches and locks are hammered out of iron or links of old chain and saddle rings. Old ropes are used to tie off gates and the knots look as intricate and fancy as a sailor's.

History means a lot to ranchers and things of the past are an important element of the ranch design. Ranchers line up old trucks and tractors and grass rakes and plows in fields and alongside fences as reminders of the past. Workhorse harnesses and old horse tack hang on the walls in barns and homes and bunkhouses like artwork. A roll of old barbed

Double R Ranch
Picabo, Idaho

wire leaning against the tin wall of the shop becomes a sculpture as do the pile of horseshoes and the snubbing post in the old corral.

This design and apparent disorder becomes the style of any ranch. I love going to all the different western states and seeing the different styles of each ranch I visit. It is fascinating and beautiful, like a living painting—the mesquite thorns of south Texas, the cactus plants of Arizona and New Mexico, the red rocks of Utah. All these elements of the natural surrounding terrain become part of a ranch's design. It seems that the geography and setting shape the people who live there and the people then shape each ranch to fit into the setting. I first noticed this pattern in the clothes and gear that ranchers wore and used and how it affected the everyday life. It also carried over to the layout and design of the ranch.

This book is a collection of photographs of the things that caught my eye at different ranches. They are items that are functional, yet they add so much to the art and design of a ranch and are a graphic expression of the West. I hope that these images will show you the special style that so many ranches share. Next time you see a beautiful overhead ranch entrance gate or a tractor sitting in a field you will understand why it was placed just so. The rancher put it there and all I did was capture it on film. He saw it first and meant for it to be a part of his style, his landscape, his living artwork. It is an expression of his personal ranch style.

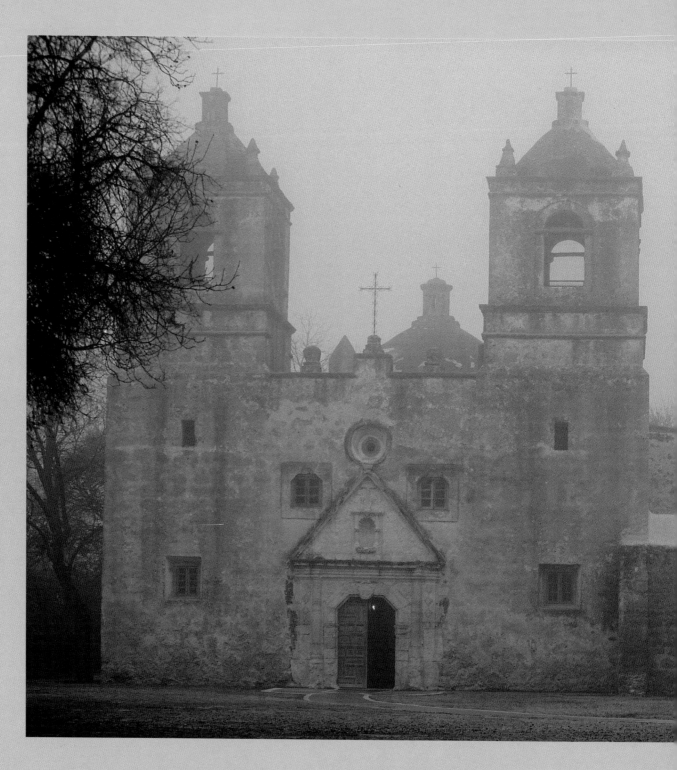

Mission Concepcion
San Antonio, Texas

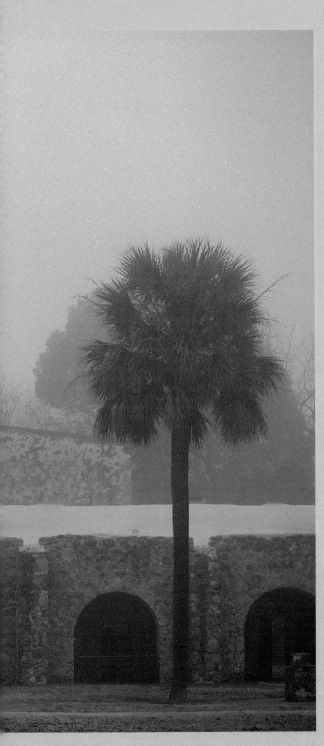

The missions marked the beginning of ranches in the Americas.

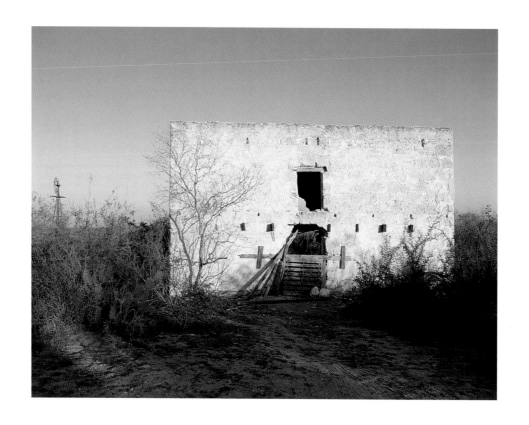

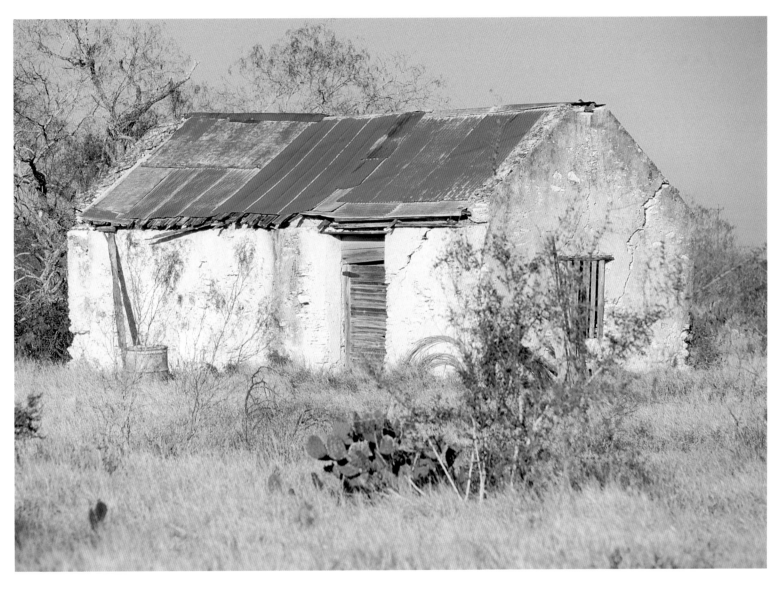

Settlers cabins, circa 1840
Linn, Texas

These are original Texas ranch houses. They are no more than 35 miles from the Mexican border and are the beginning of ranches in the western United States.

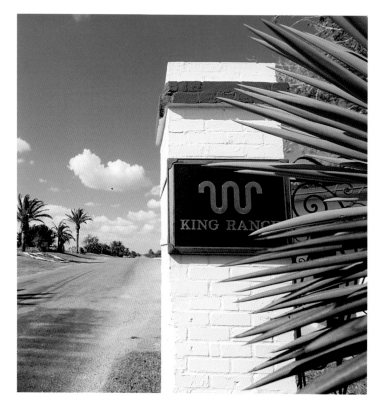

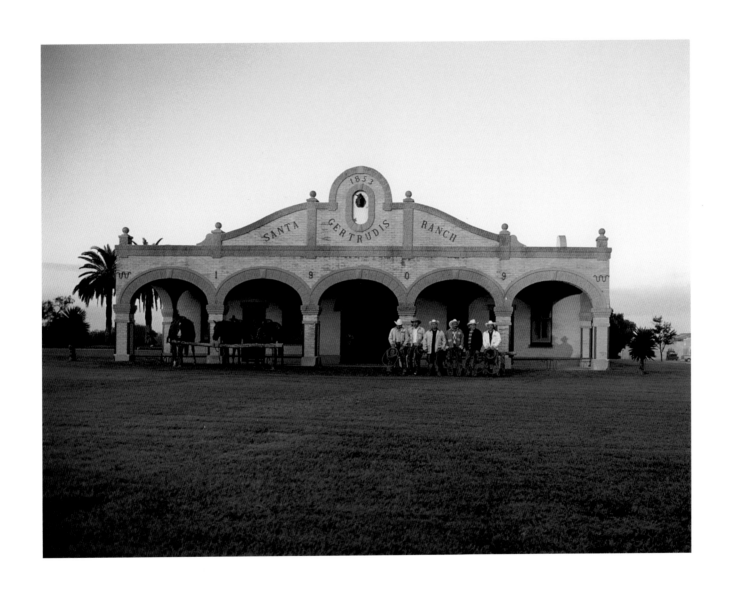

The King Ranch in Kingsville, Texas was established in 1853.
It was the prototype of the American cattle ranch.

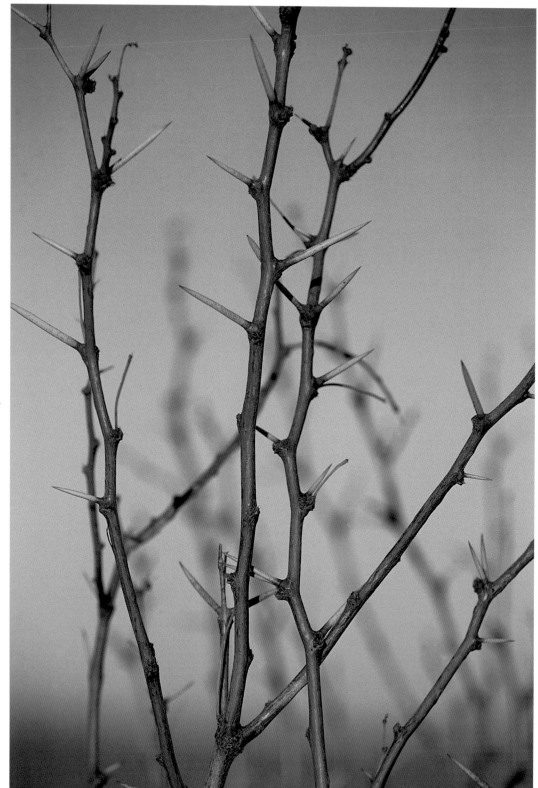

Mesquite thorns

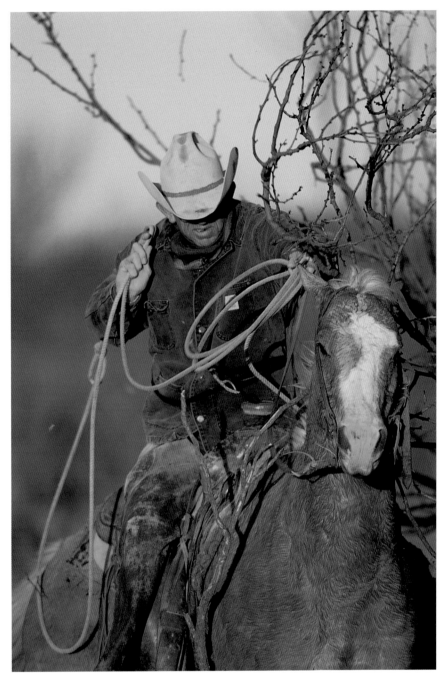

It is the geography that makes the ranch. Sometimes it is the harsh landscape. Tom Moorhouse rides his horse through the deep mesquite. His clothes and equipment show the wear and tear of the thorns.

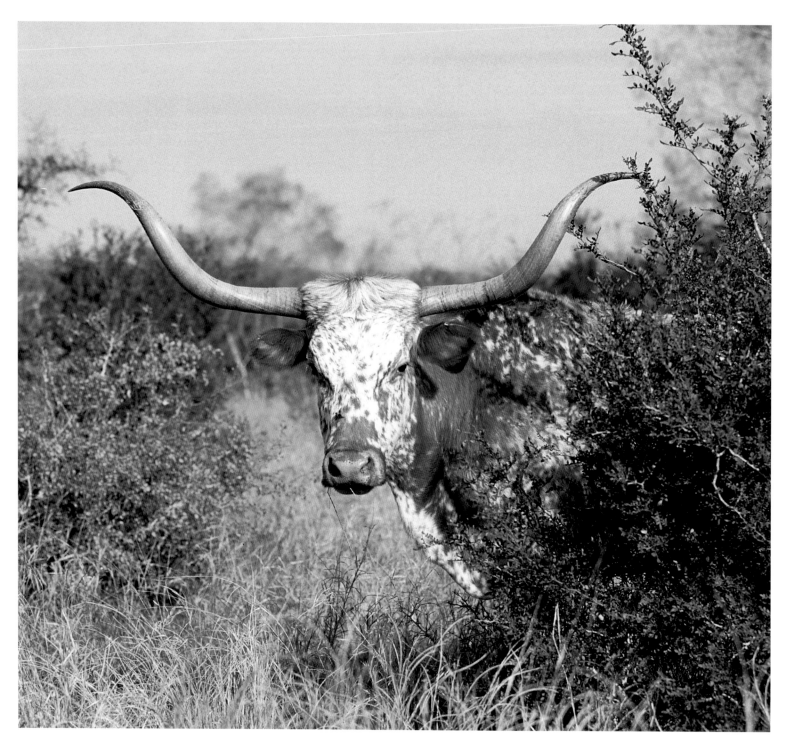

Longhorn steer
San Vicente Ranch
Linn, Texas

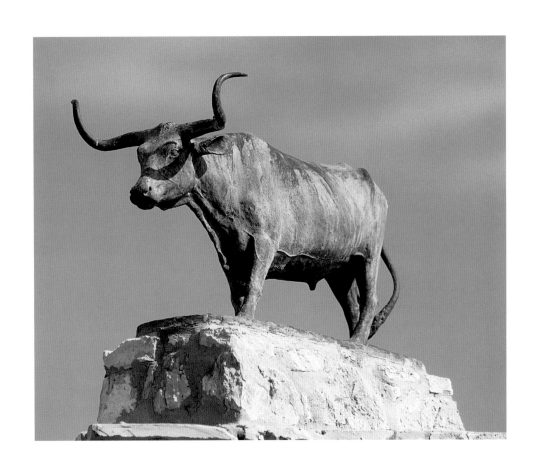

Bronze gatepost ornament
San Vicente Ranch
Linn, Texas

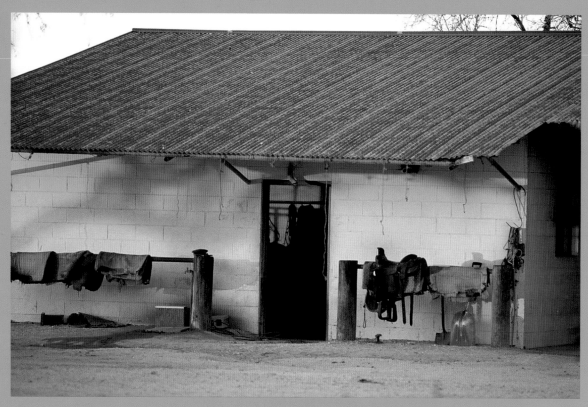

Saddle house
McAllen Ranch
Linn, Texas

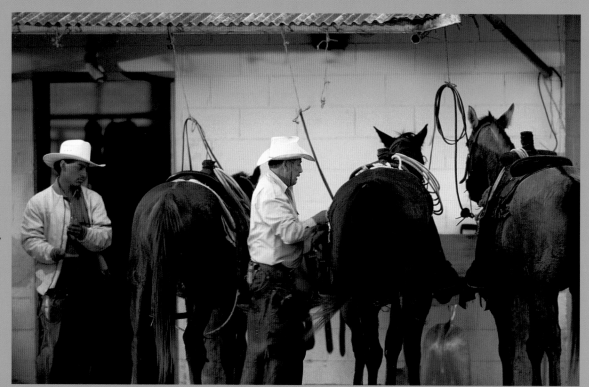

Raul Trevino and
Homer Vela Ramos
McAllen Ranch
Linn, Texas

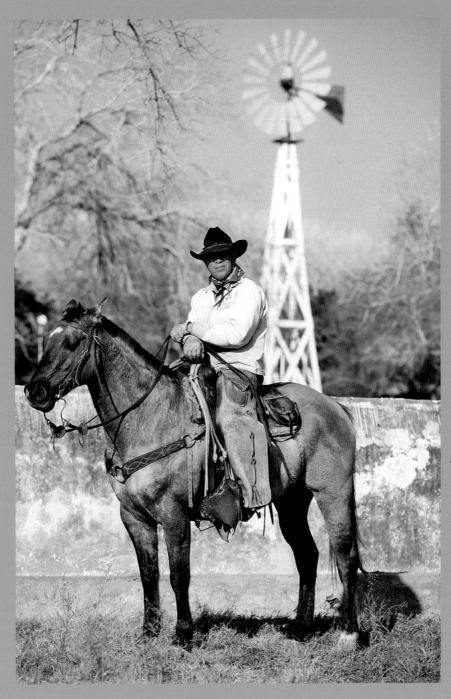

Juan Luis Longoria
McAllen Ranch
Linn, Texas

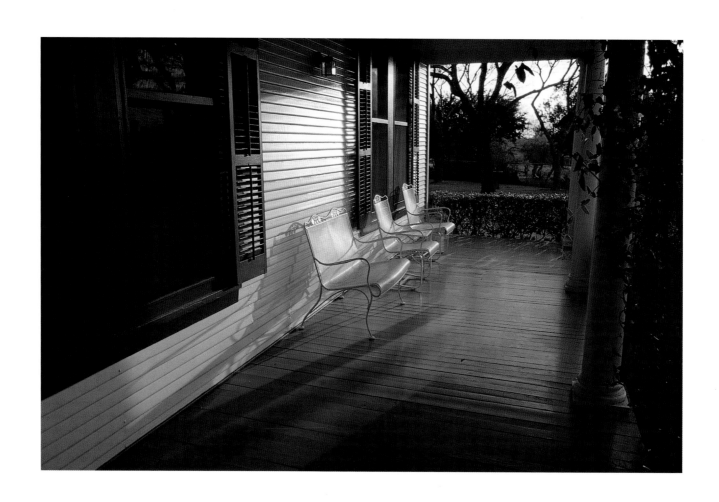

Porch
McAllen Ranch
Linn, Texas

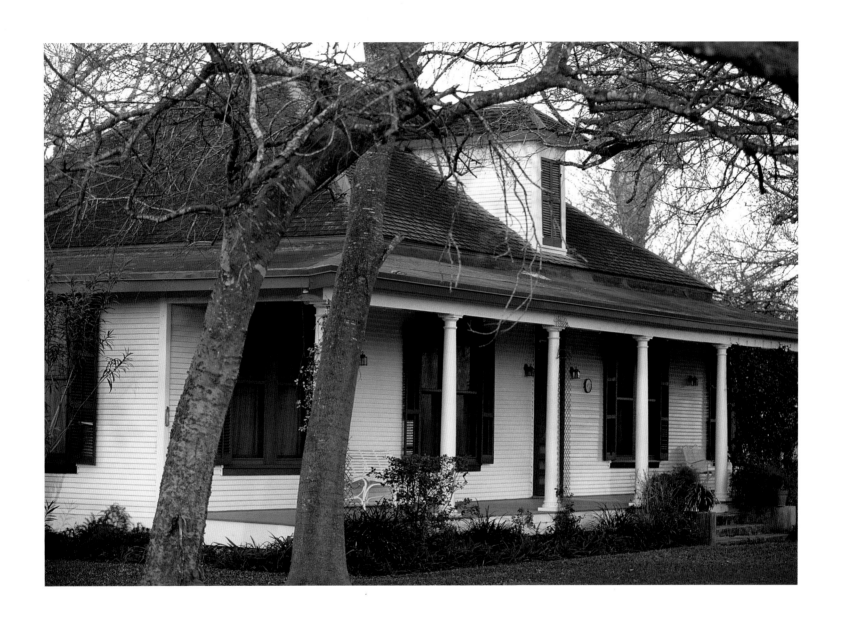

Ranch house
McAllen Ranch
Linn, Texas

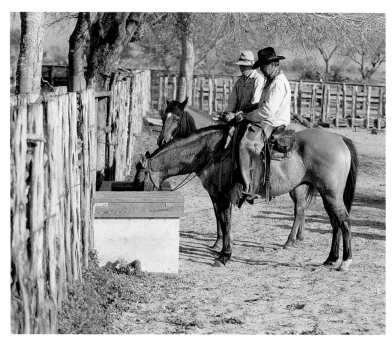

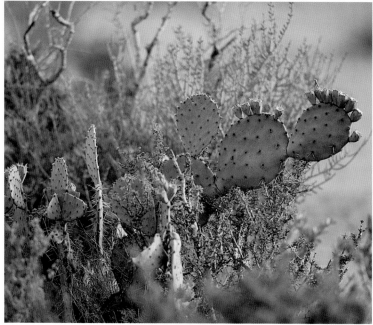

Water trough, Juan Luis Longoria and Raul Treviño
McAllen Ranch
Linn, Texas

Prickly pear cactus
South Texas

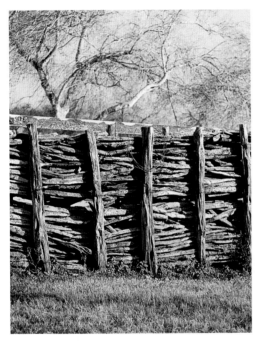

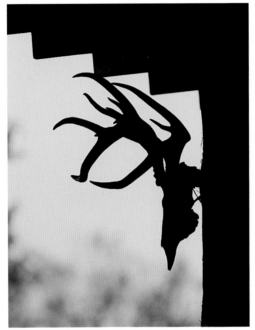

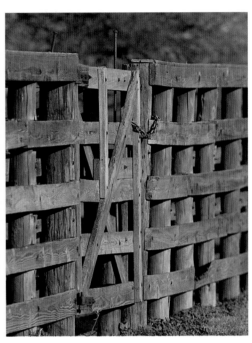

Mesquite fence
McAllen Ranch
Linn, Texas

Deer skull
Saunders Ranch
Weatherford, Texas

Stock gate and fence
McAllen Ranch
Linn, Texas

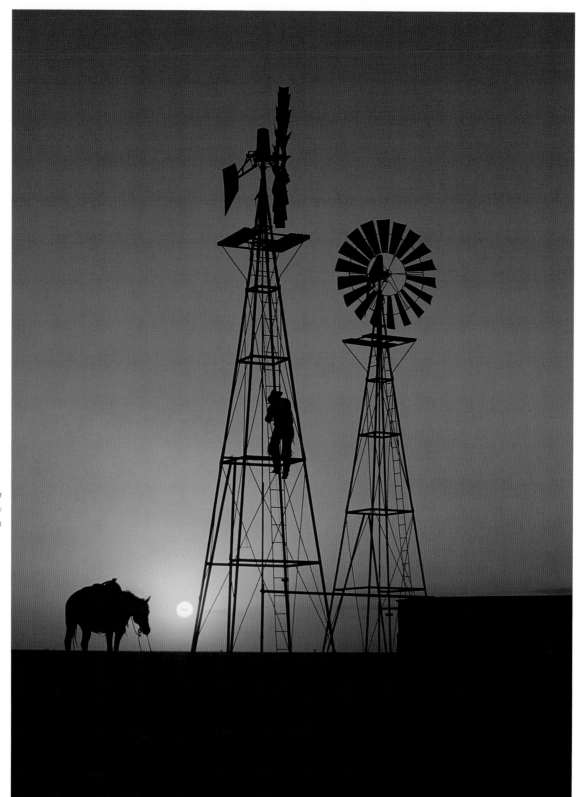

Jim Detten
Harrell Cattle Company
Claude, Texas

26

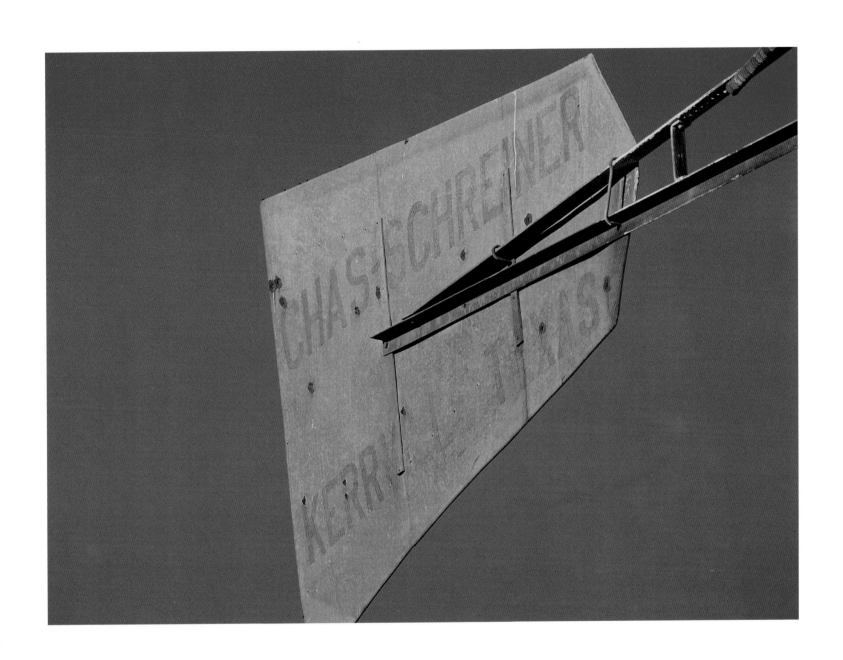

Windmill fan
YO Ranch
Mountain Home, Texas

West Texas prairie
Pitchfork Ranch
Guthrie, Texas

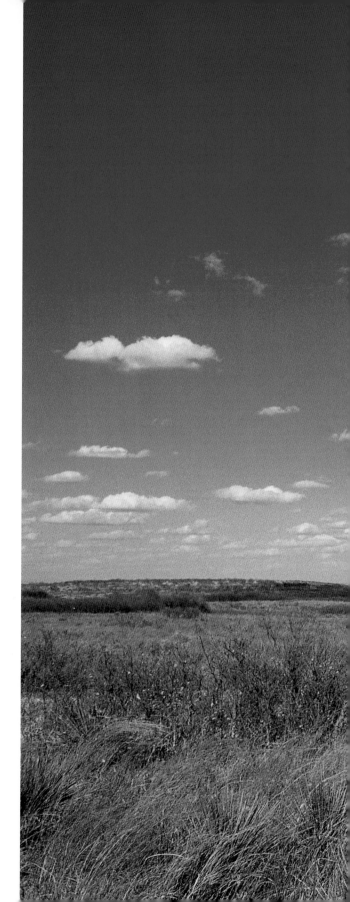

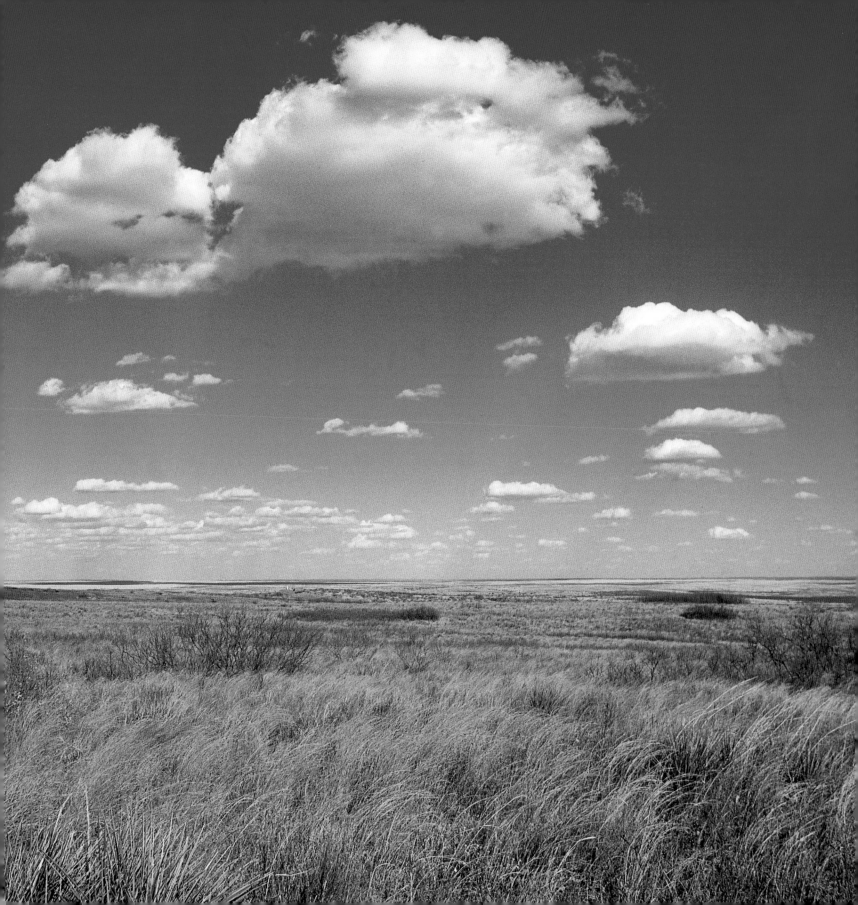

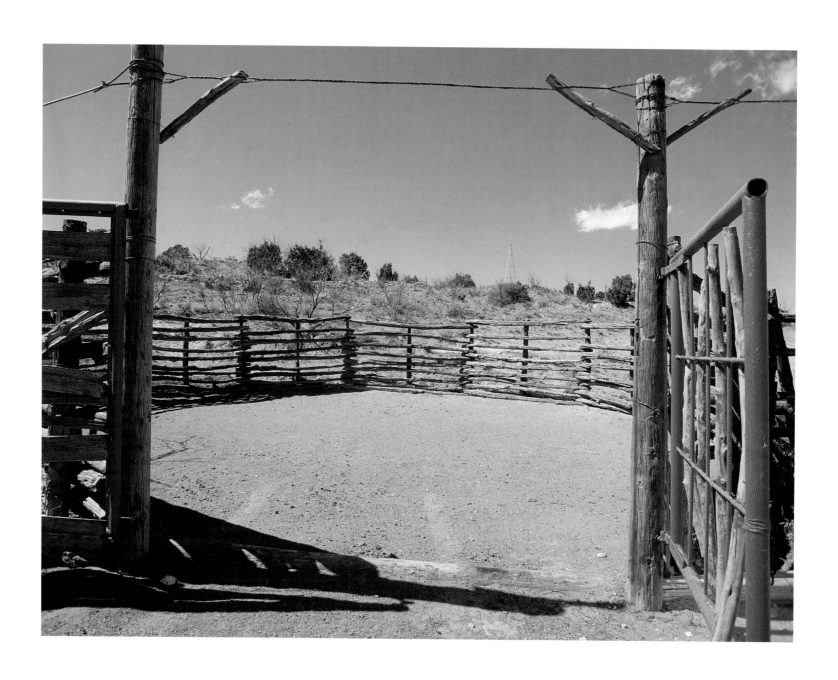

Round pen
Pitchfork Ranch
Guthrie, Texas

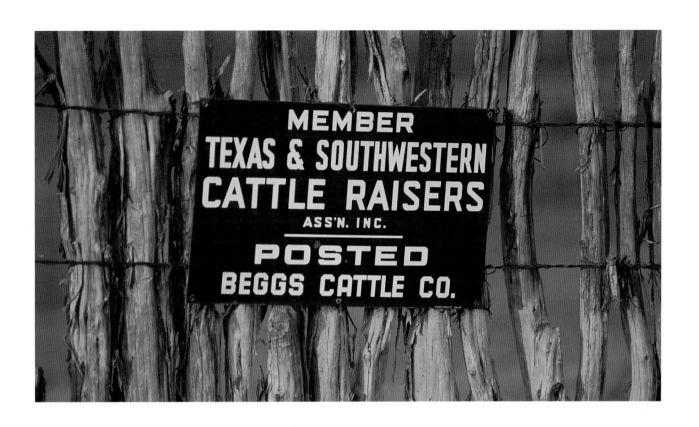

Texas ranch signs

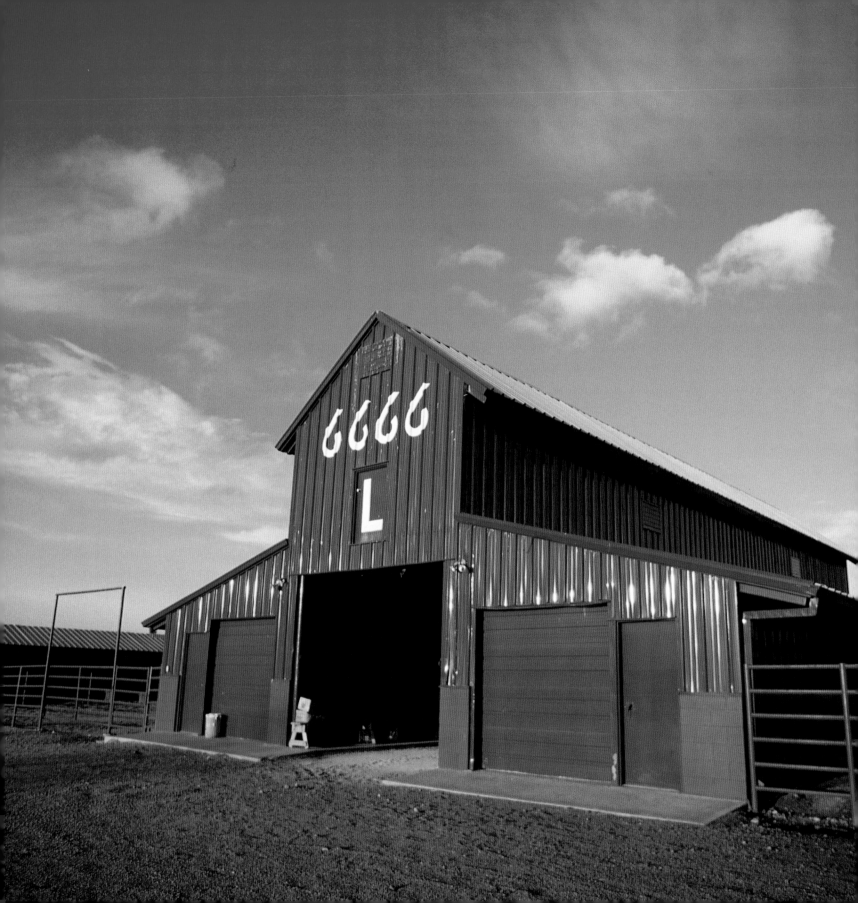

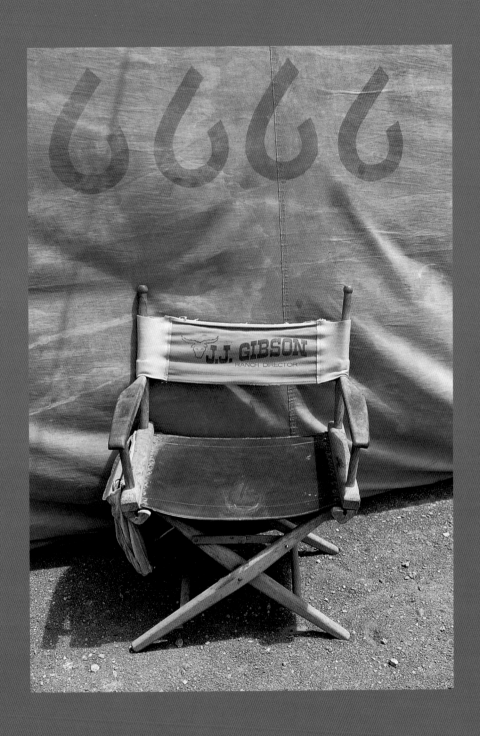

One of the most famous barns in the West
6666 Ranch
Guthrie, Texas

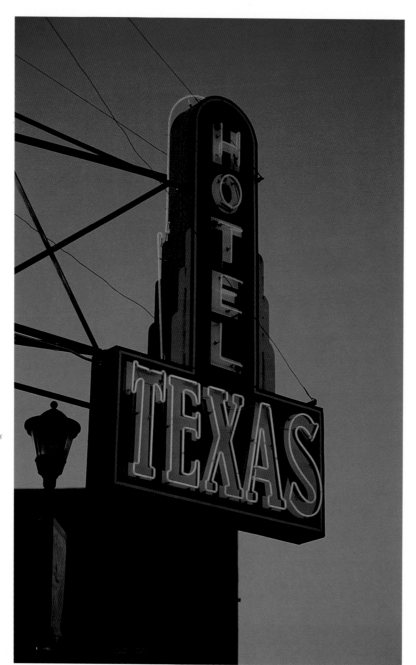

Fort Worth, Texas

34

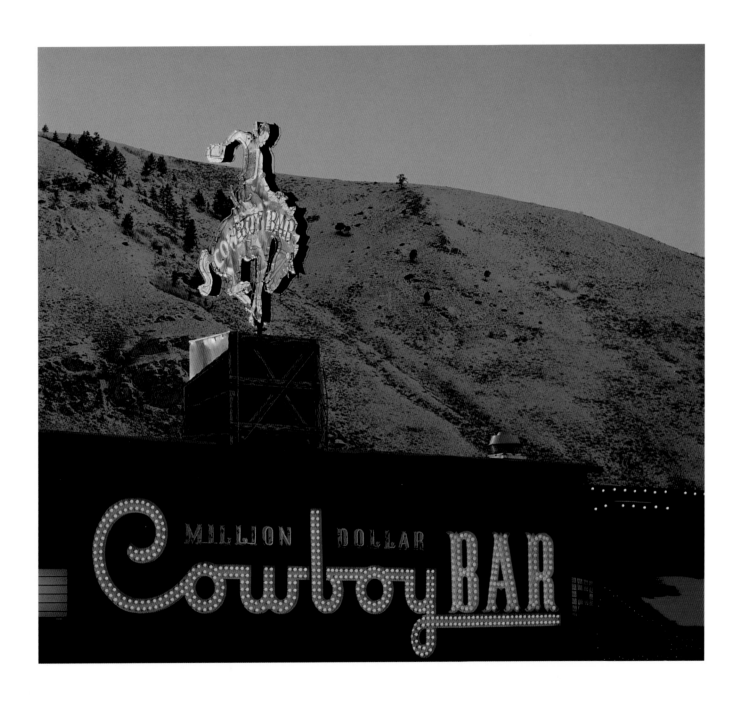

Jackson, Wyoming

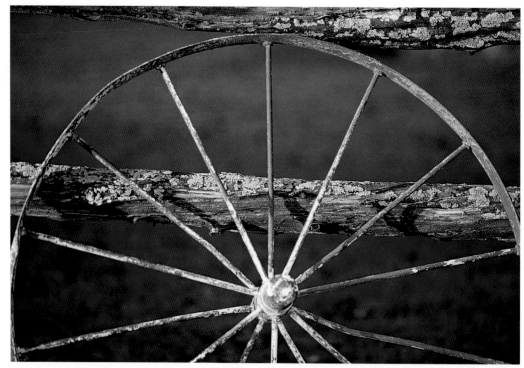

Old wheel
Twin V Ranch
Weatherford, Texas

Barbed wire
Pitchfork Ranch
Guthrie, Texas

Chuck wagon wheel
Pitchfork Ranch
Guthrie, Texas

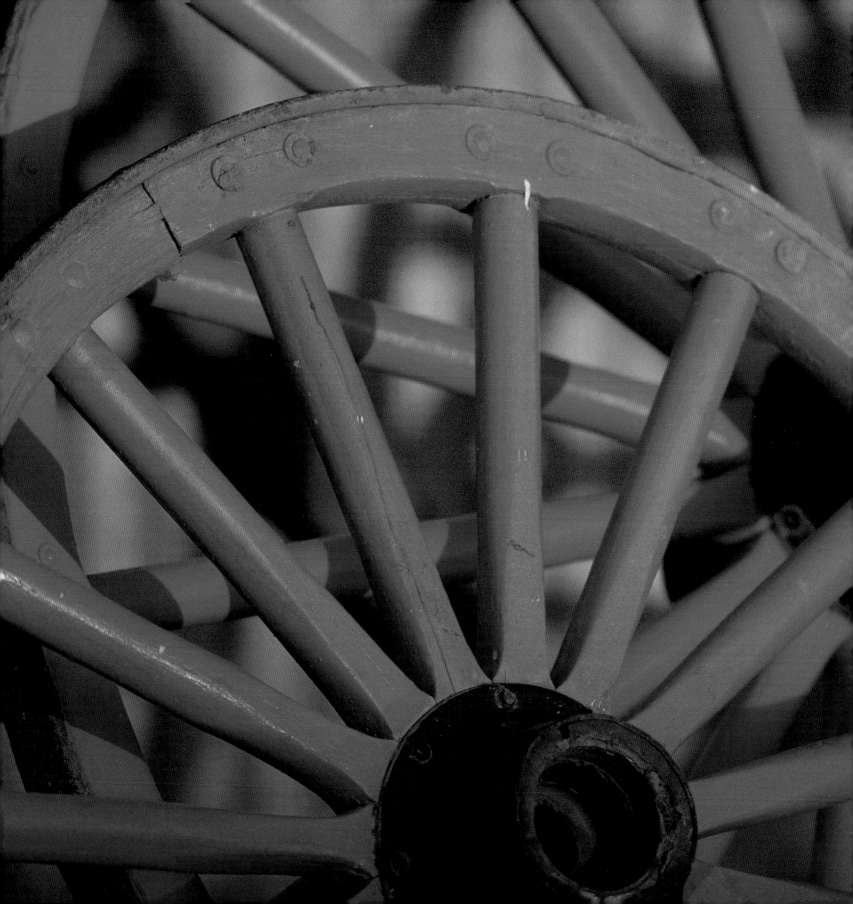

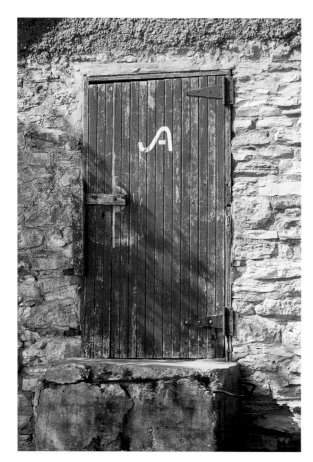

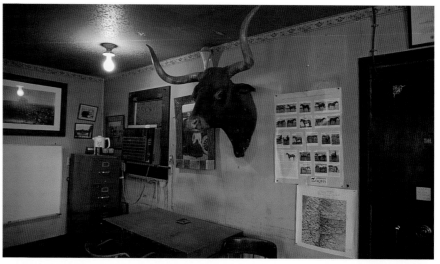

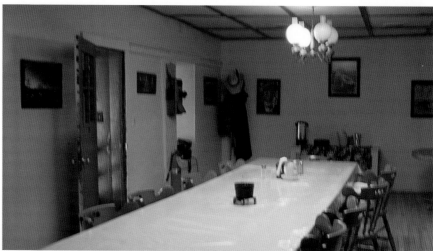

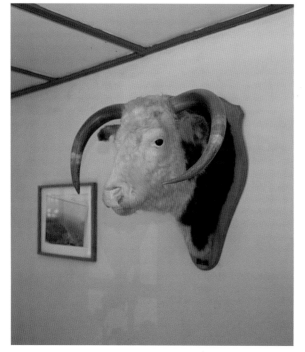

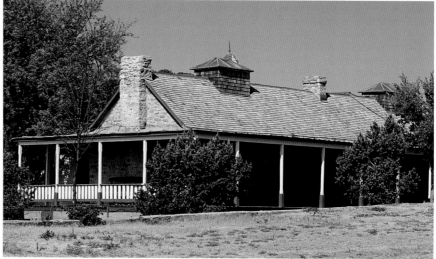

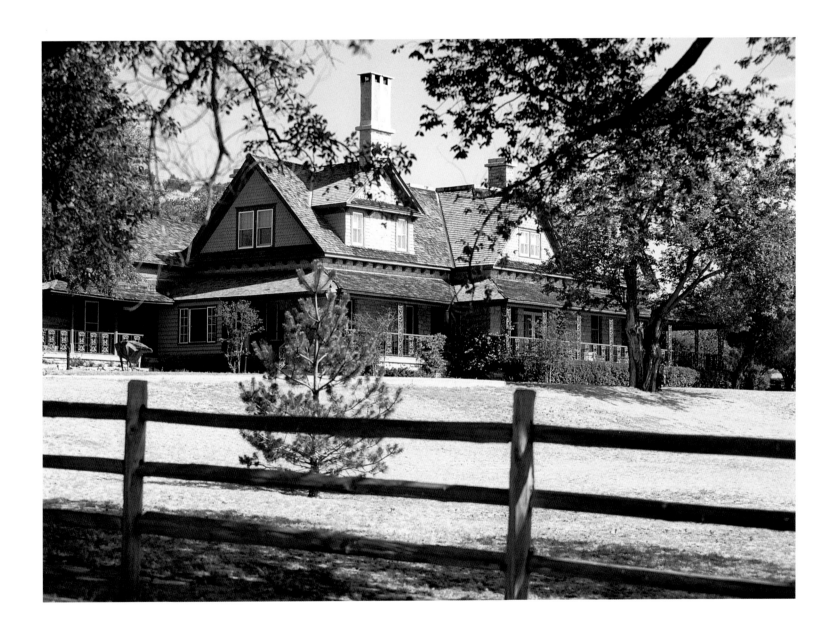

Main House
JA Ranch
Clarendon, Texas

Bunk house, cook shack and office
JA Ranch
Clarendon, Texas

39

Beggs Ranch
Post, Texas

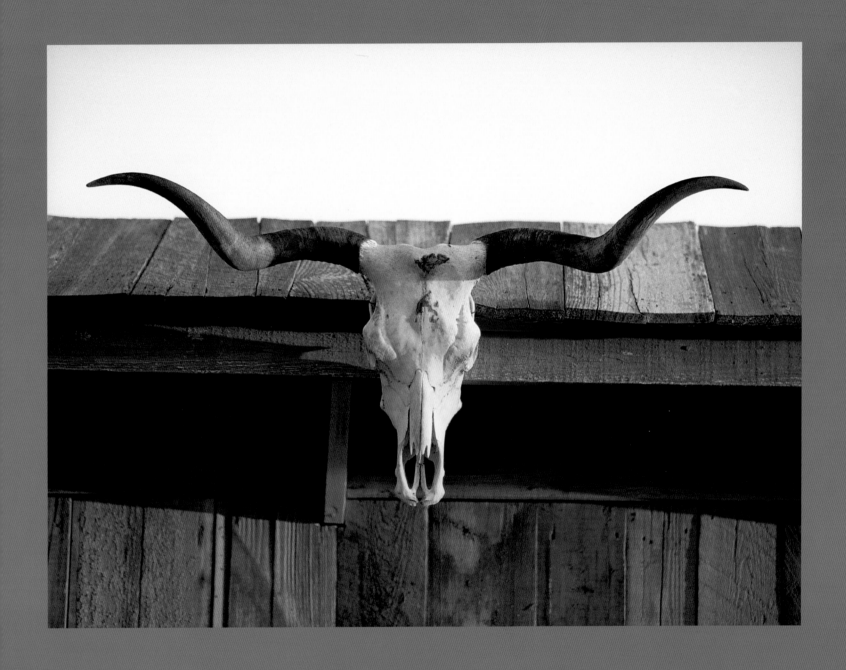

YO Ranch
Mountain Home, Texas

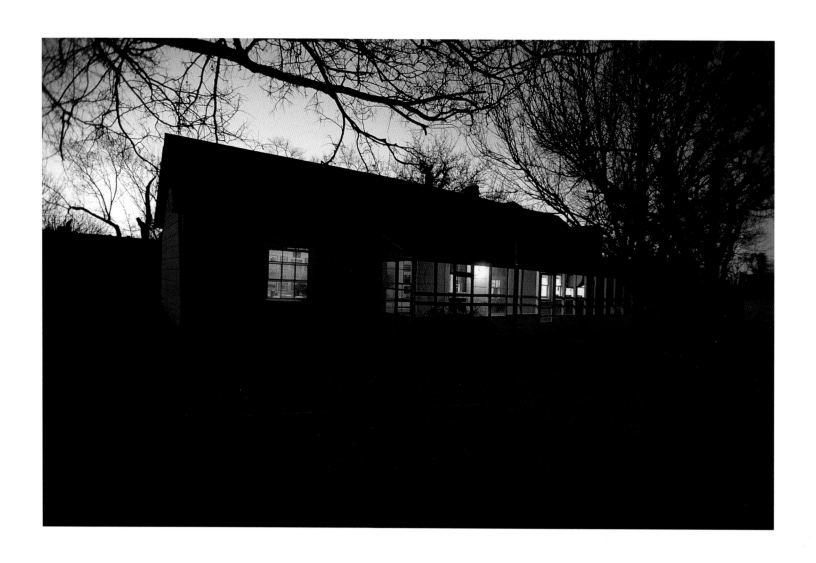

Cook shack
Pitchfork Ranch
Guthrie, Texas

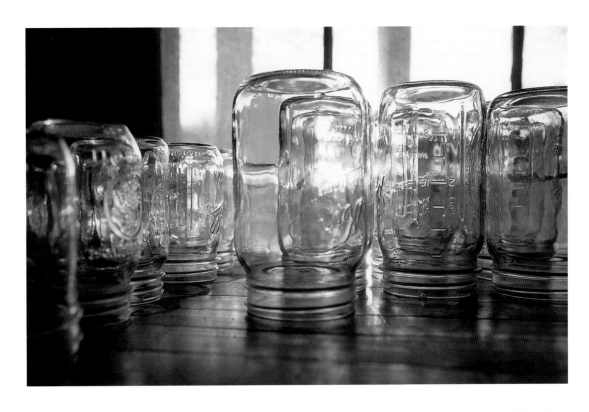

Water glasses

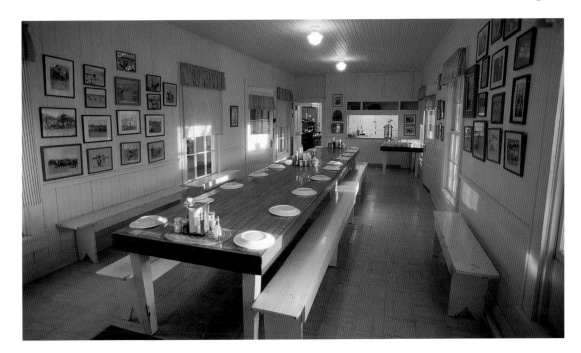

Dining hall
Pitchfork Ranch
Guthrie, Texas

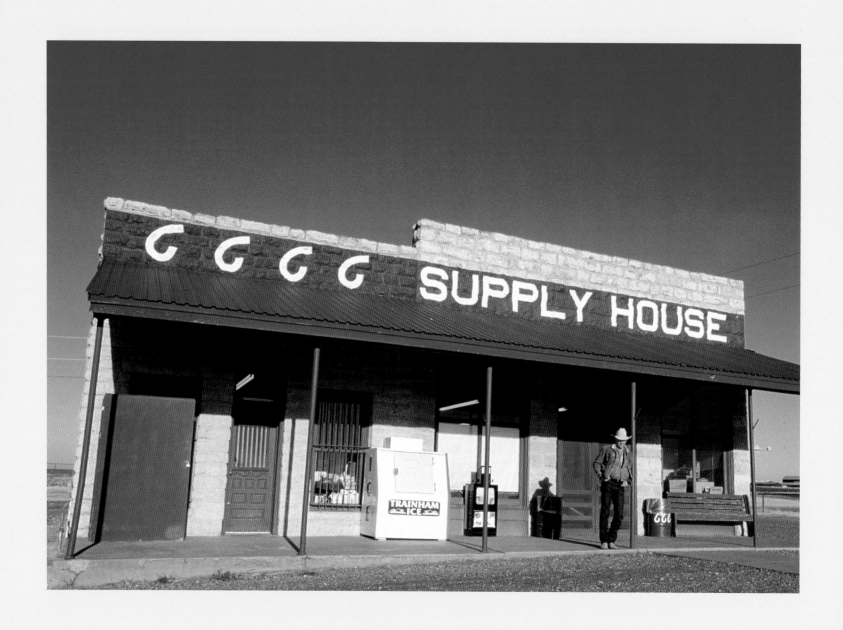

Terry Lambeth
6666 Ranch
Guthrie, Texas

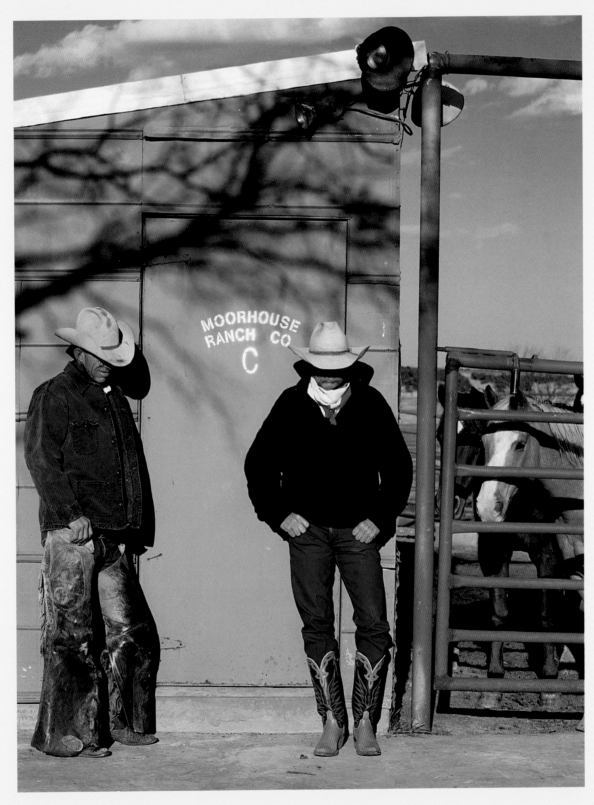

*Tom and
Bob Moorhouse
Benjamin, Texas*

45

Roping dummy
Dunne Ranch
Hollister, California

Roping dummy
Rancho Mission Viejo
San Juan Capistrano, California

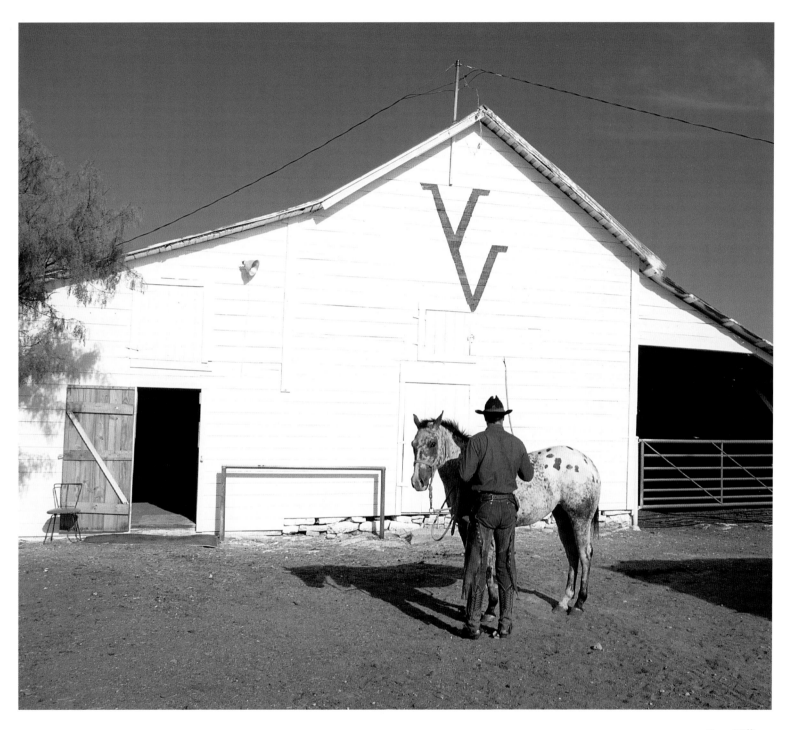

Perry Williams
Twin V Ranch
Weatherford, Texas

YO Ranch
...ntain Home, Texas

Picabo, Idaho

Big Hole, Monta

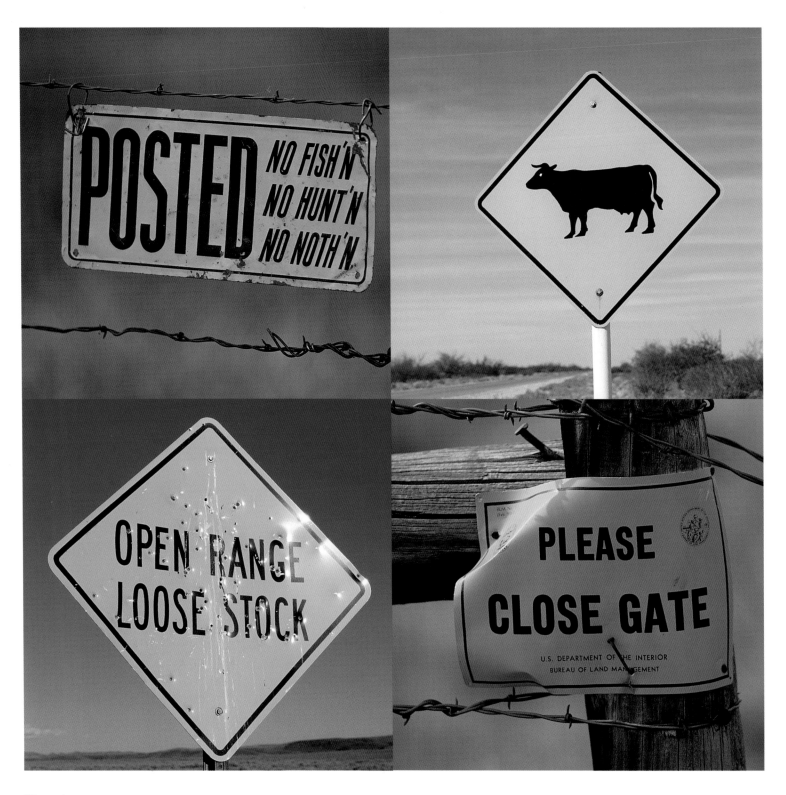

Western signs

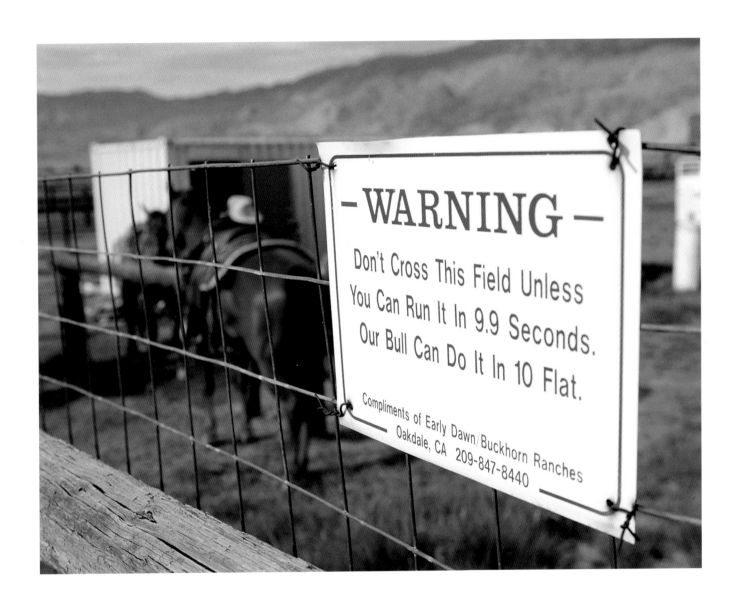

Lacey Livestock
Independence, California

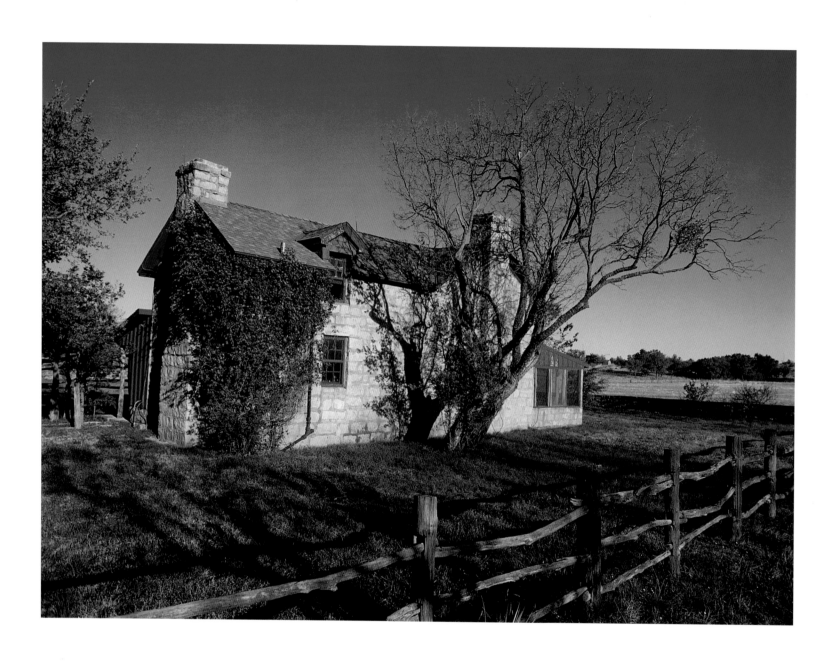

Main house
Lambshead Ranch
Albany, Texas

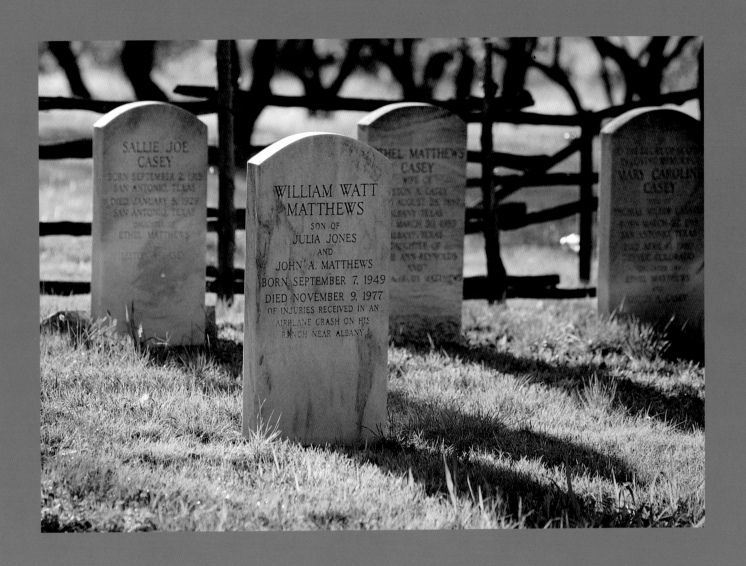

Graveyard
Lambshead Ranch
Albany, Texas

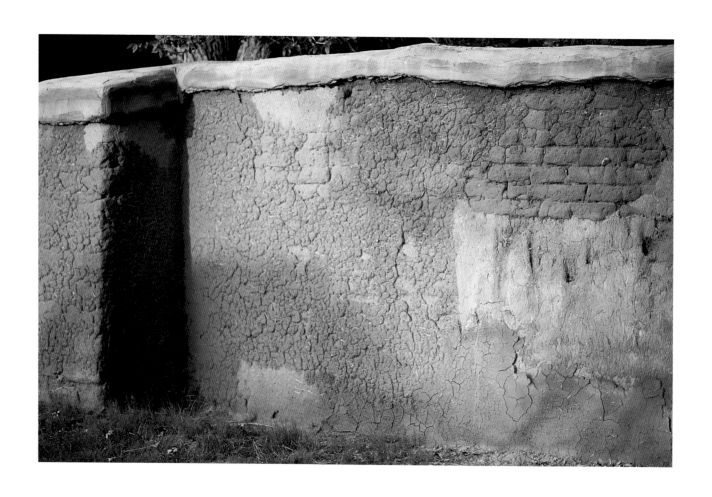

Adobe wall
Dead Horse Ranch
New Mexico

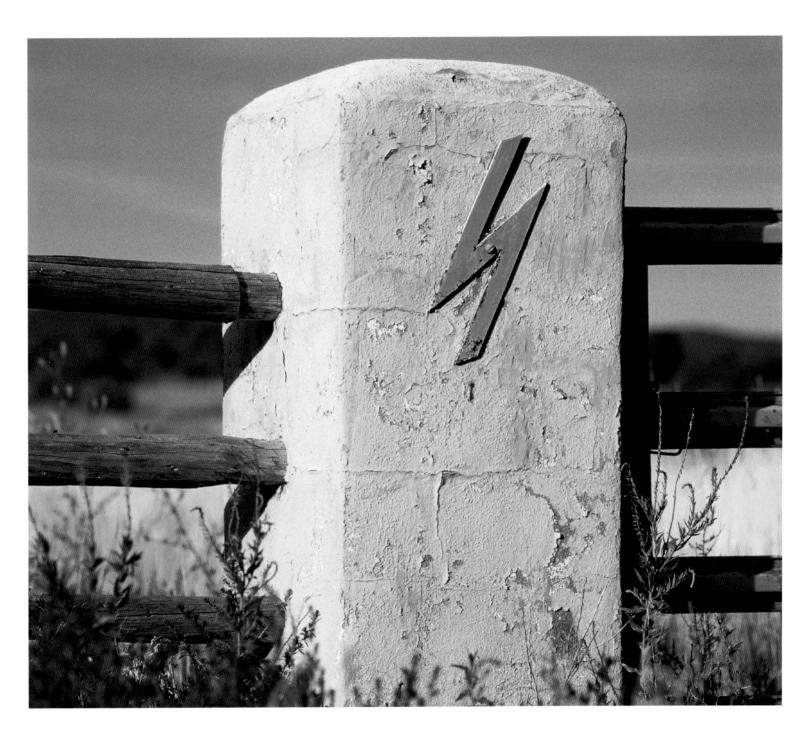

Gatepost
Old Forked Lightning Ranch
Pecos, New Mexico

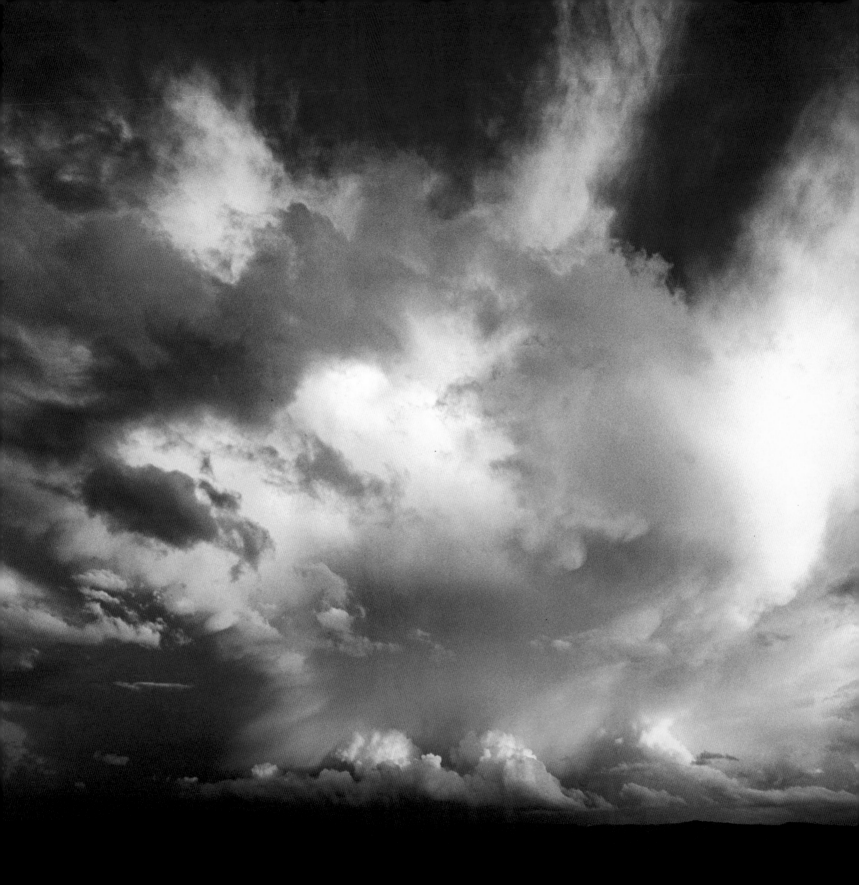

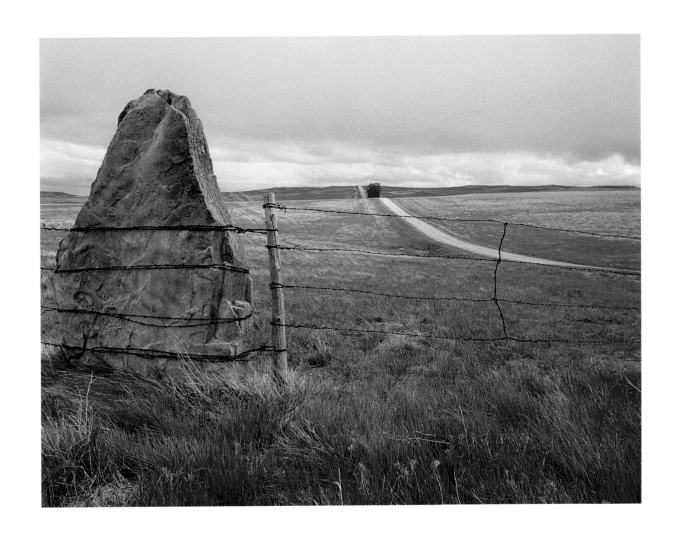

Gatepost
Jordan, Montana

Summer storm
Padlock Ranch
Montana

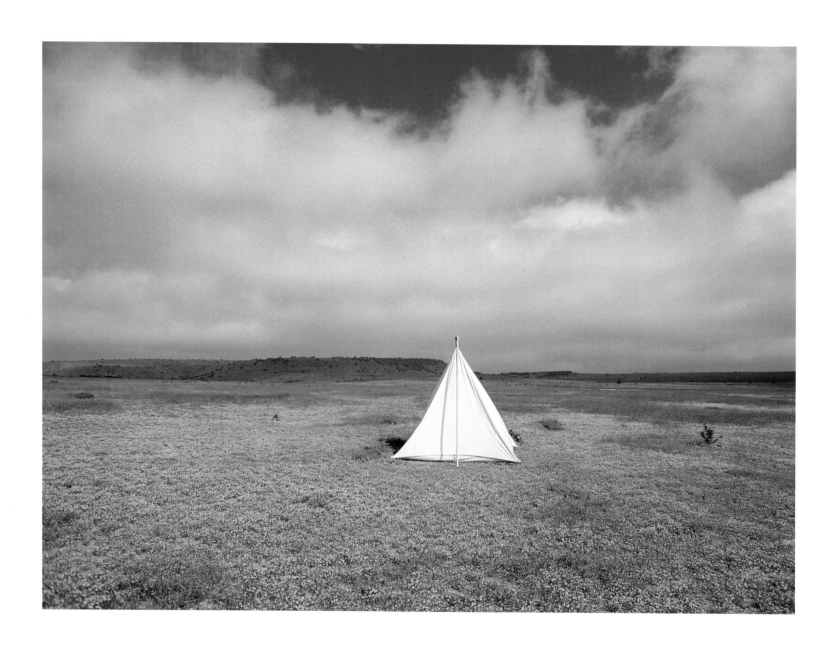

Cowboy tepee
06 Ranch
Fort Davis, Texas

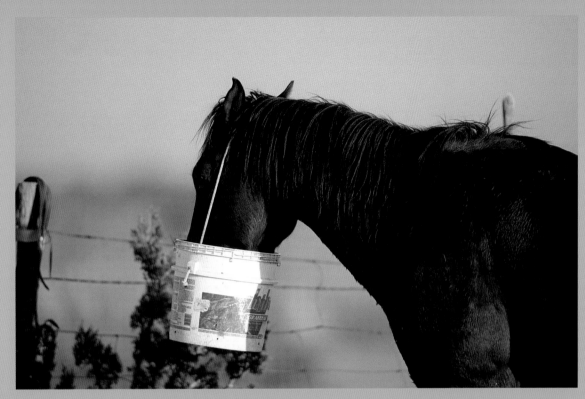

Feed bucket
06 Ranch
Fort Davis, Texas

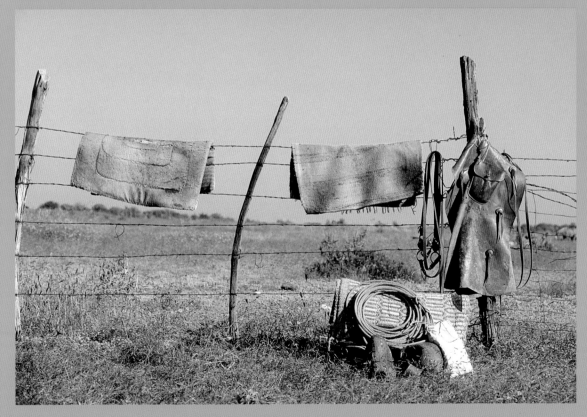

Tack room
06 Ranch
Fort Davis, Texas

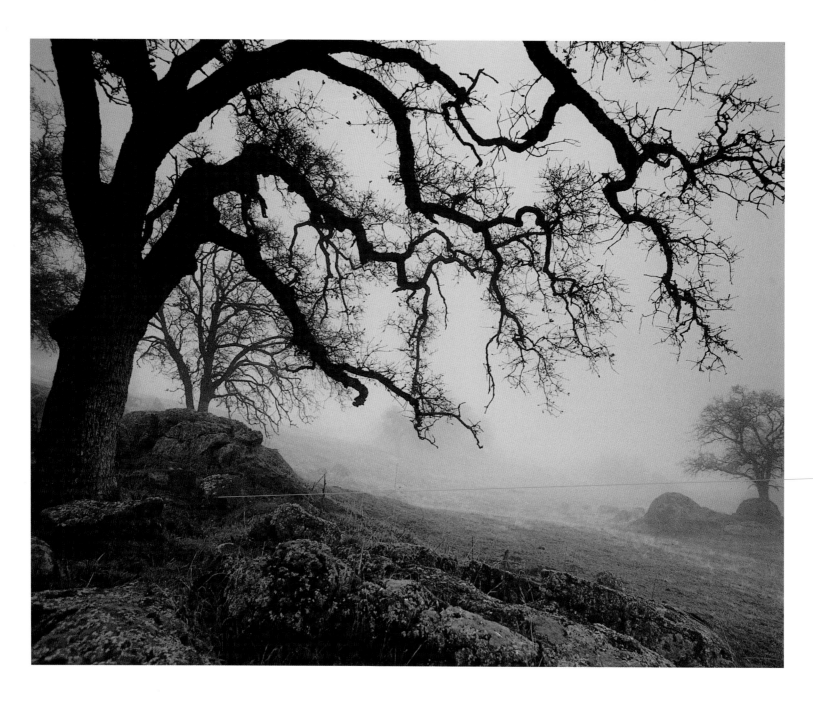

Oak tree in morning fog
Yokohl Valley Cattle Company
Yokohl Valley, California

Barn
Yokohl Valley Cattle Company
Yokohl Valley, California

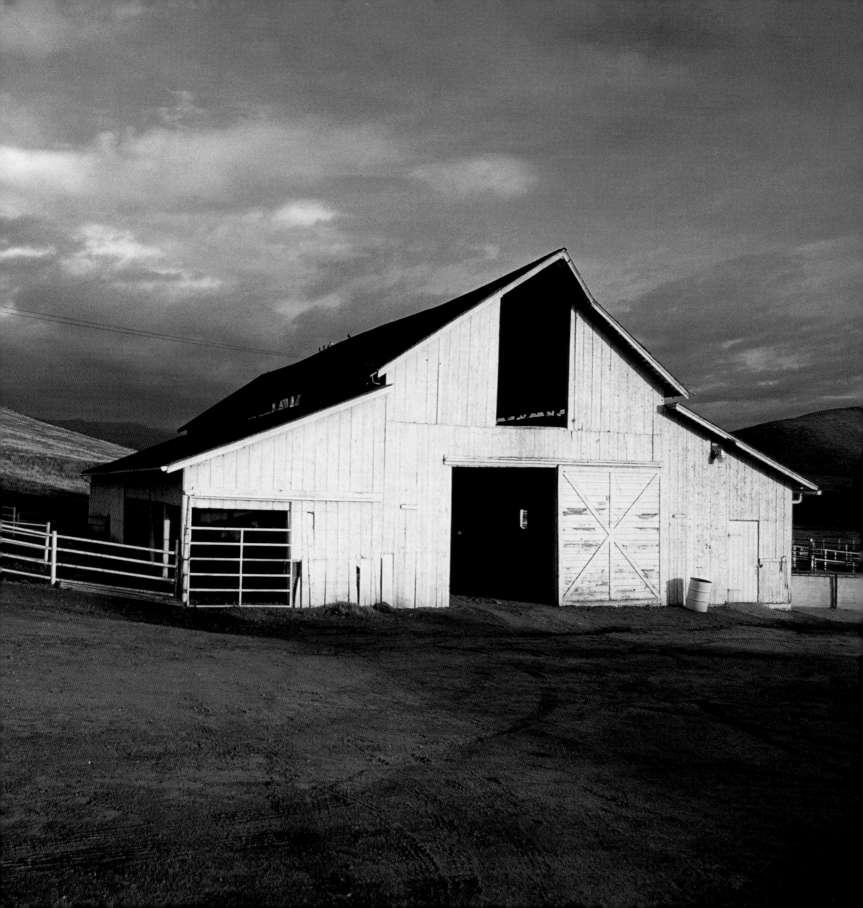

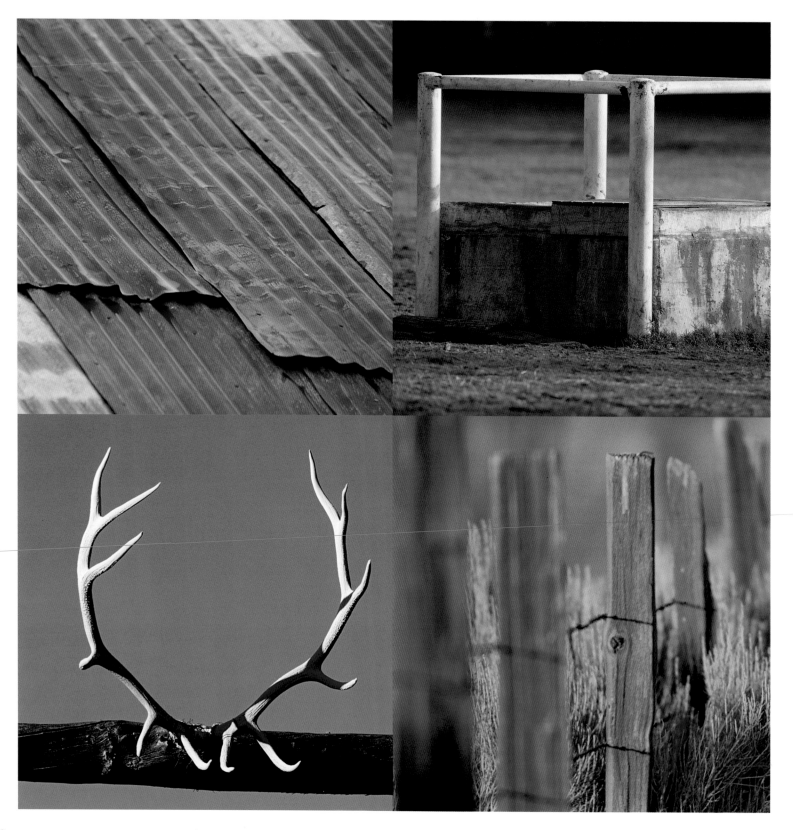

Ranch details, California, Texas, Idaho, Oregon

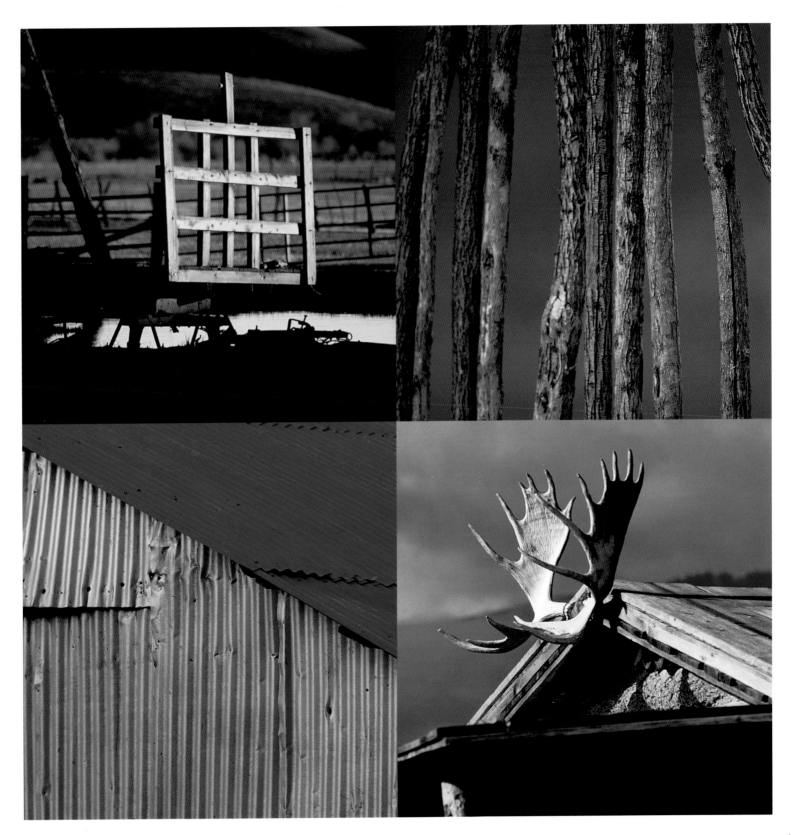

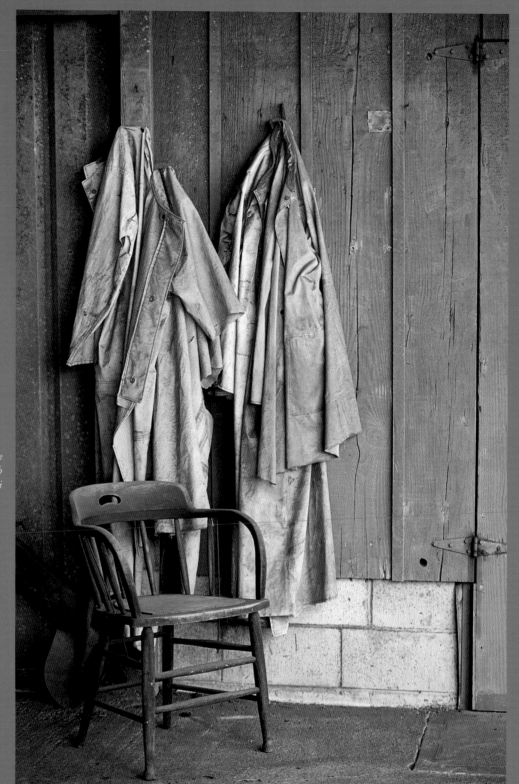

Bunkhouse
Parker Ranch
Hawaii

64

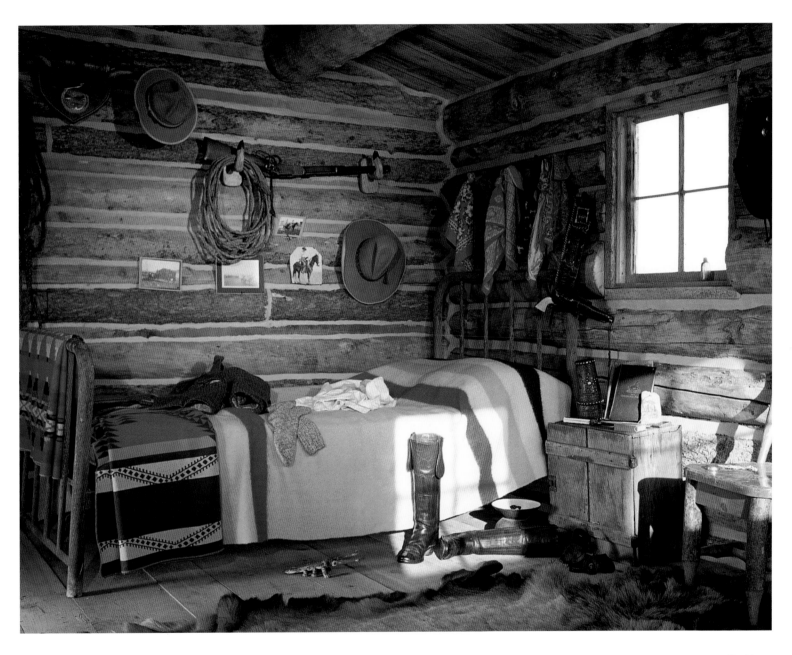

Bunkhouse
Bar Horseshoe Ranch
Mackay, Idaho

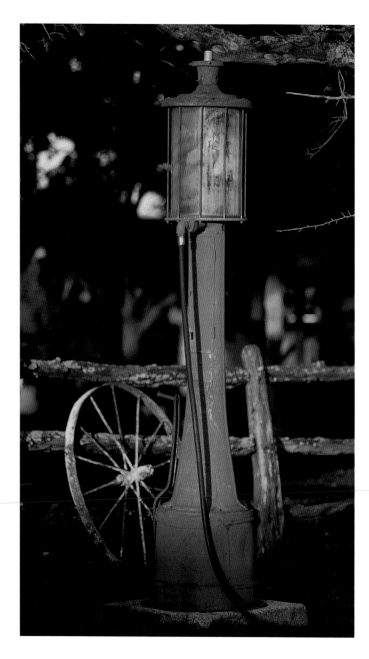

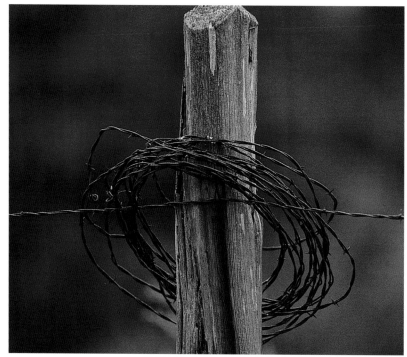

Saunders Ranch
Weatherford, Texas

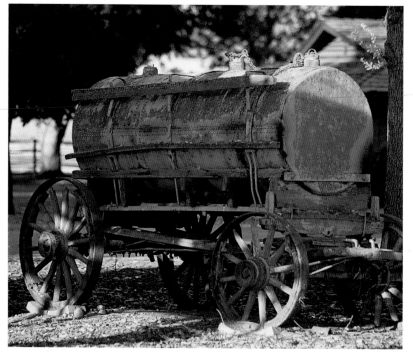

Saunders Ranch
Weatherford, Texas

Jack Ranch
Paso Robles, California

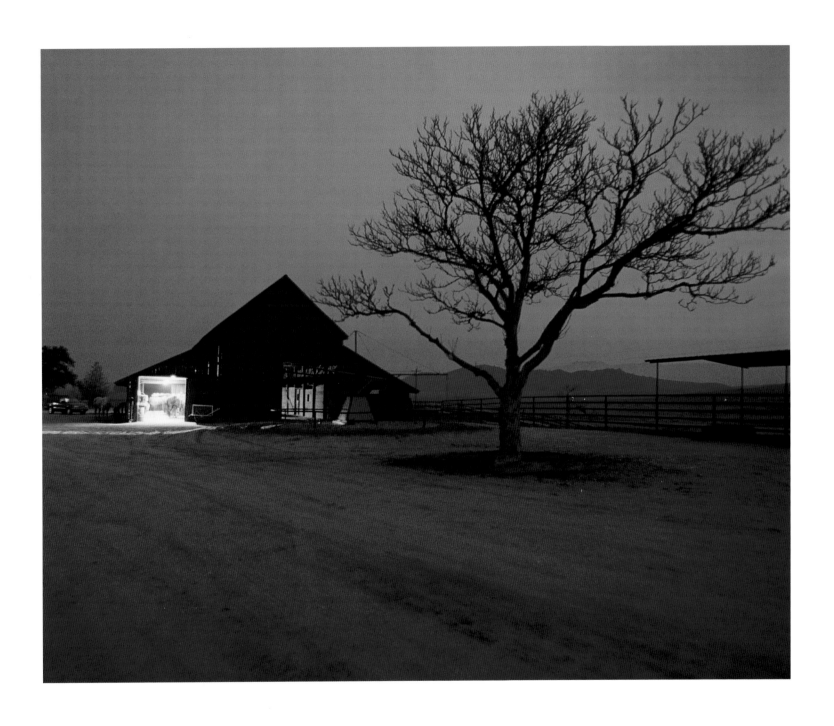

Jack Ranch
Paso Robles, California

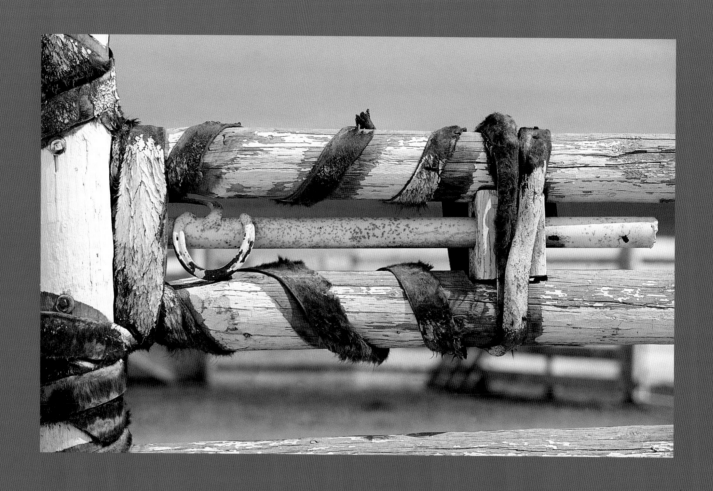

Gate latch
Binion Ranch
Jordan, Montana

Gate latch
Horse Prairie Ranch
Dillon, Montana

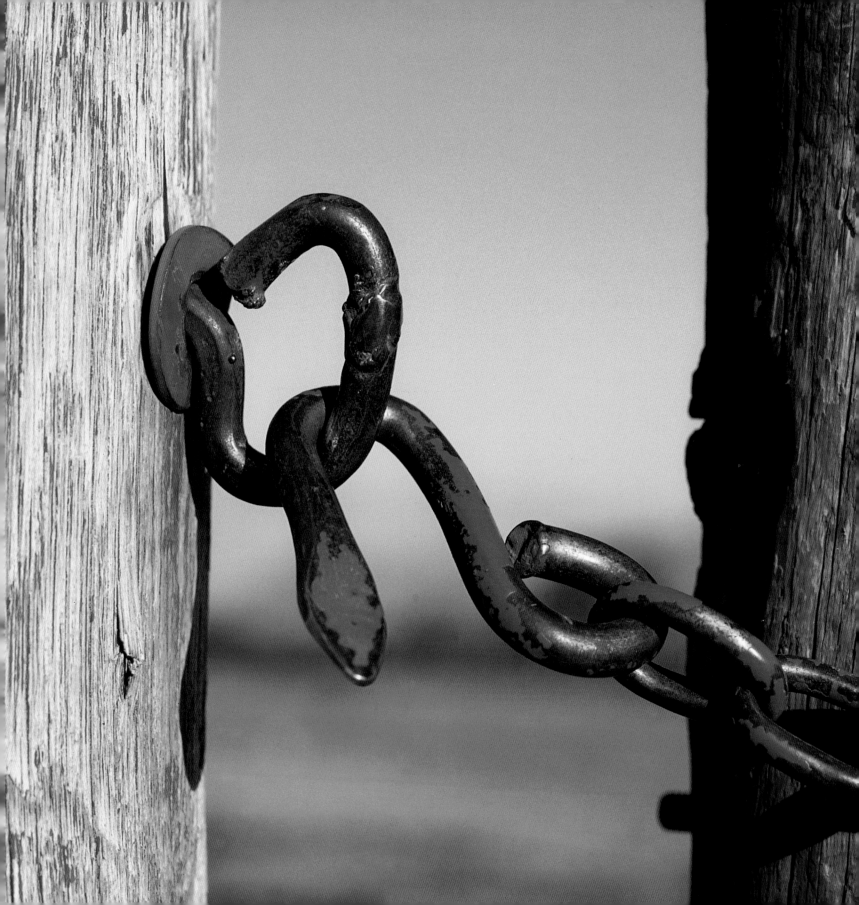

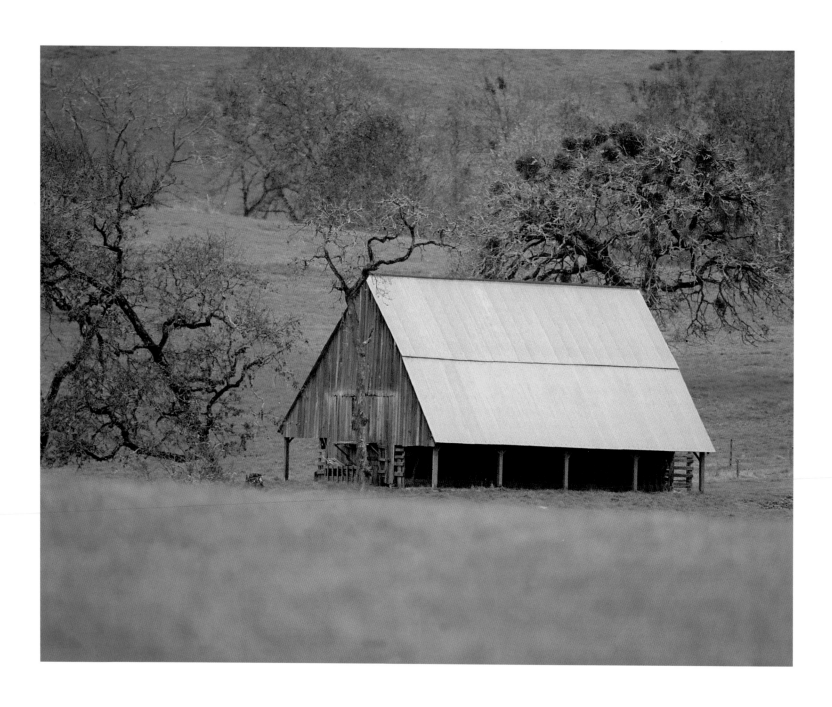

Barn
Crane Creek Ranch
Roseberg, Oregon

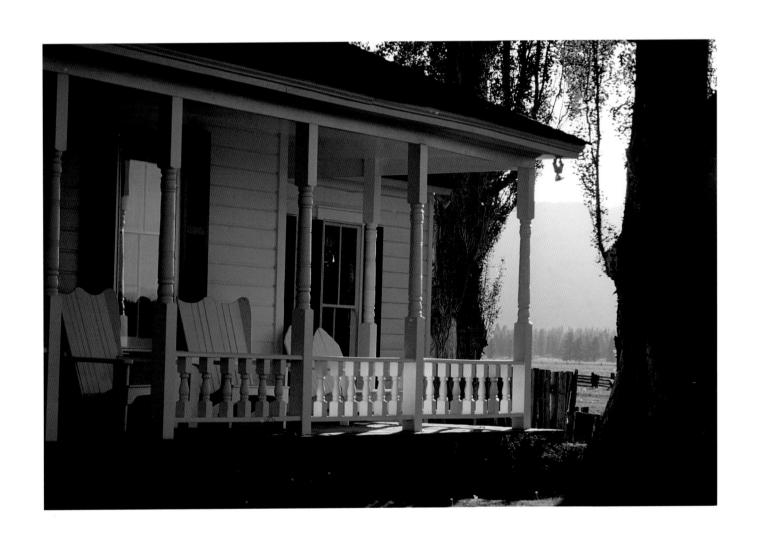

Ranch house porch
Five Dot Land & Cattle Company
Susanville, California

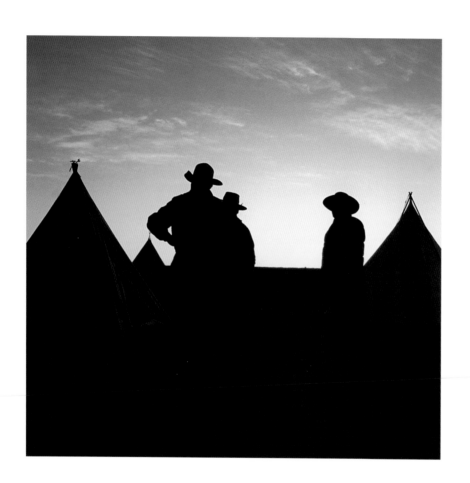

Branding camp
YP Ranch
Tuscarora, Nevada

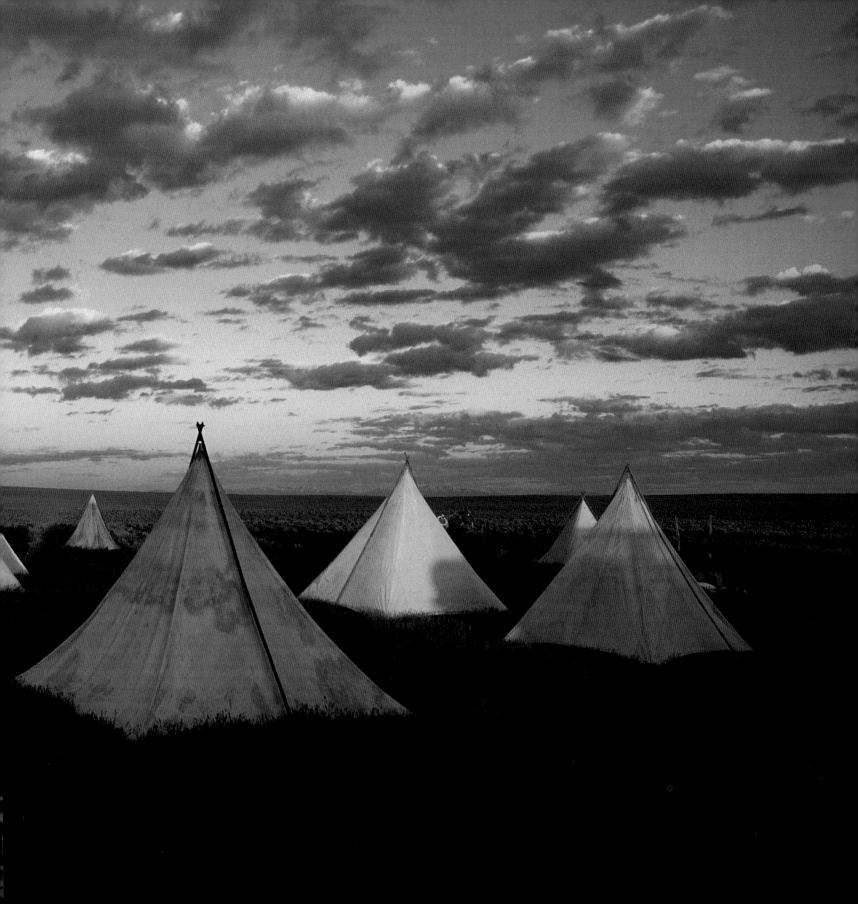

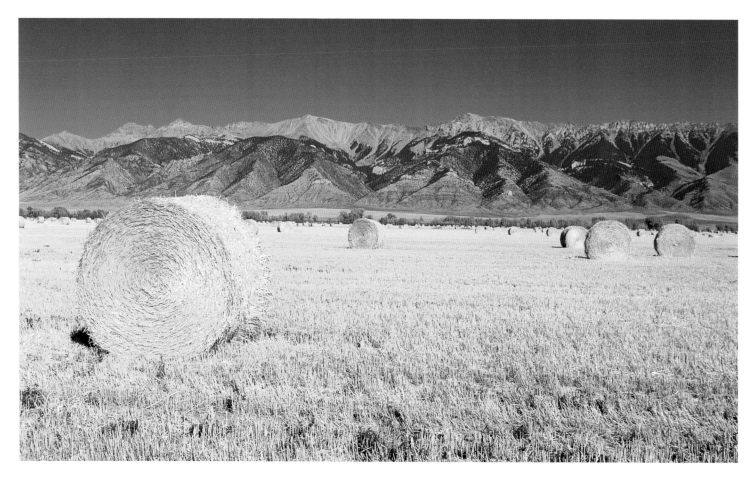

Hay field
Mackay, Idaho

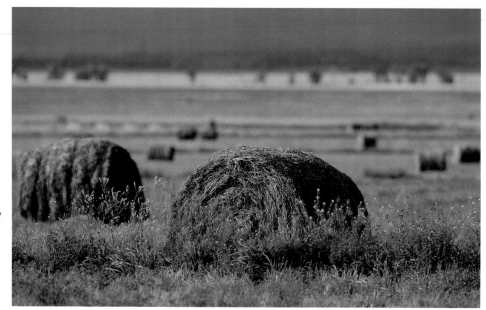

Hay field
Bozeman, Montana

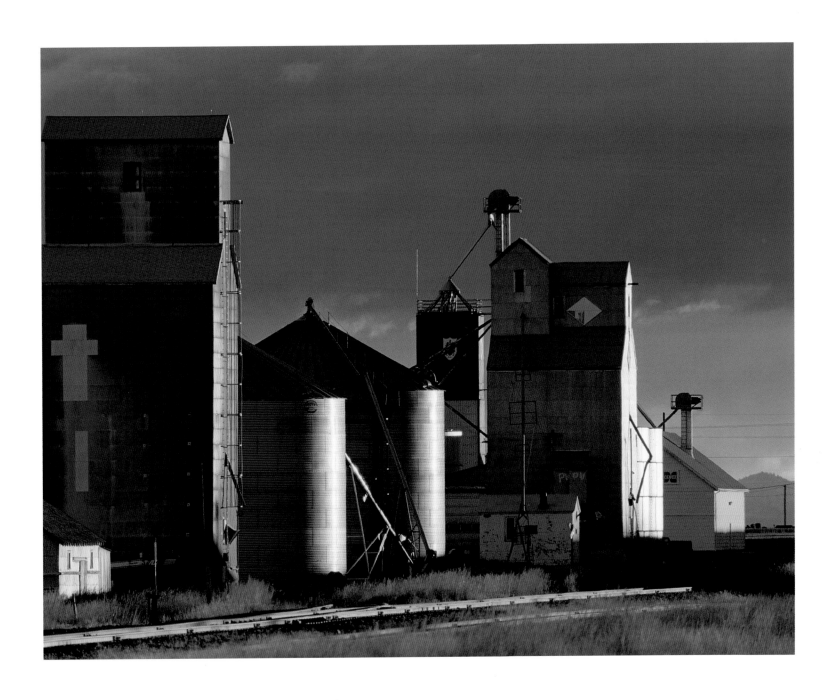

Grain elevators
Big Sandy, Montana

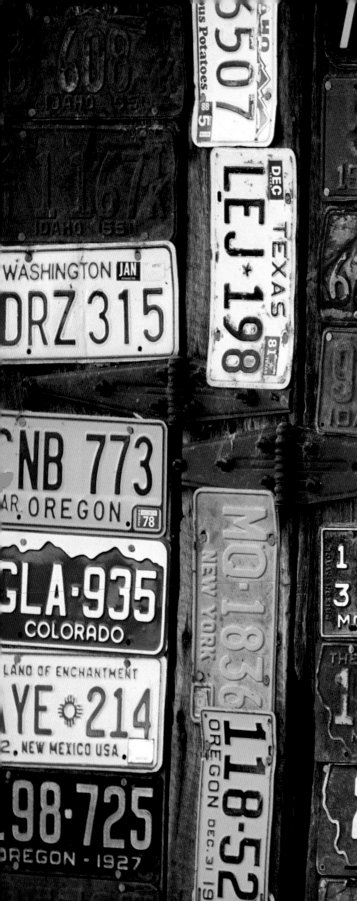
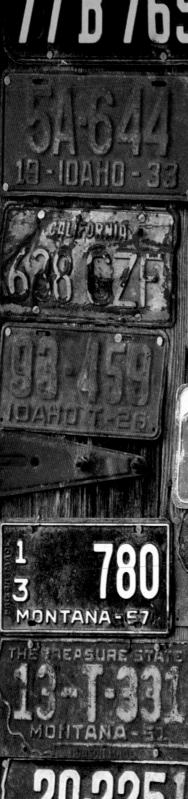
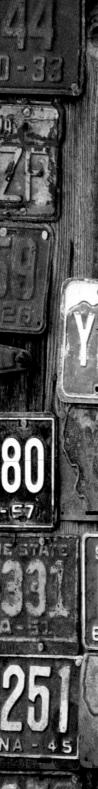
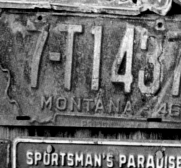
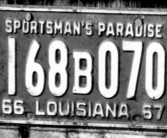
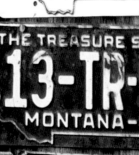

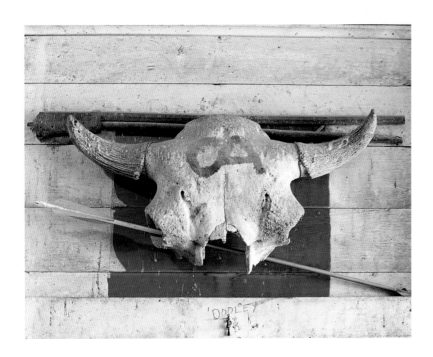

CA Ranch
Montana

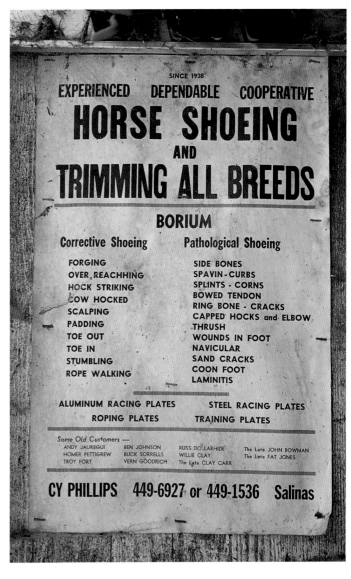

SINCE 1938

EXPERIENCED DEPENDABLE COOPERATIVE

HORSE SHOEING
AND
TRIMMING ALL BREEDS

BORIUM

Corrective Shoeing	Pathological Shoeing
FORGING	SIDE BONES
OVER REACHHING	SPAVIN - CURBS
HOCK STRIKING	SPLINTS - CORNS
COW HOCKED	BOWED TENDON
SCALPING	RING BONE - CRACKS
PADDING	CAPPED HOCKS and ELBOW
TOE OUT	THRUSH
TOE IN	WOUNDS IN FOOT
STUMBLING	NAVICULAR
ROPE WALKING	SAND CRACKS
	COON FOOT
	LAMINITIS

ALUMINUM RACING PLATES	STEEL RACING PLATES
ROPING PLATES	TRAINING PLATES

Some Old Customers —
ANDY JAUREGUI BEN JOHNSON RUSS DOLLARHIDE The Late JOHN BOWMAN
HOMER PETTIGREW BUCK SORRELLS WILLIE CLAY The Late FAT JONES
TROY FORT VERN GOODRICH The Late CLAY CARR

CY PHILLIPS 449-6927 or 449-1536 Salinas

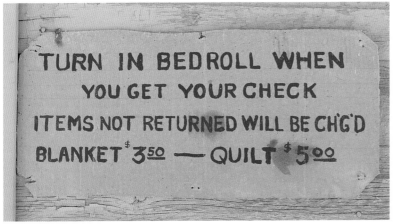

TURN IN BEDROLL WHEN
YOU GET YOUR CHECK
ITEMS NOT RETURNED WILL BE CHG'D
BLANKET $3⁵⁰ — QUILT $5⁰⁰

Dunne Ranch
Hollister, California

Hirschy Ranch
Big Hole, Montana

Barn wall
Susie Q Ranch
Picabo, Idaho

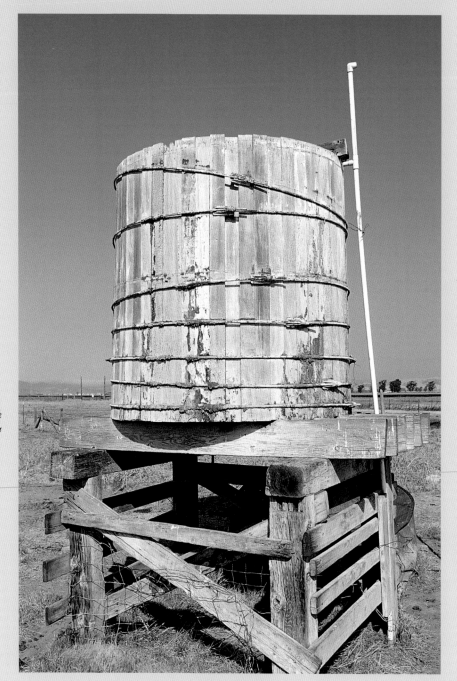

Water tank
Fairfield, California

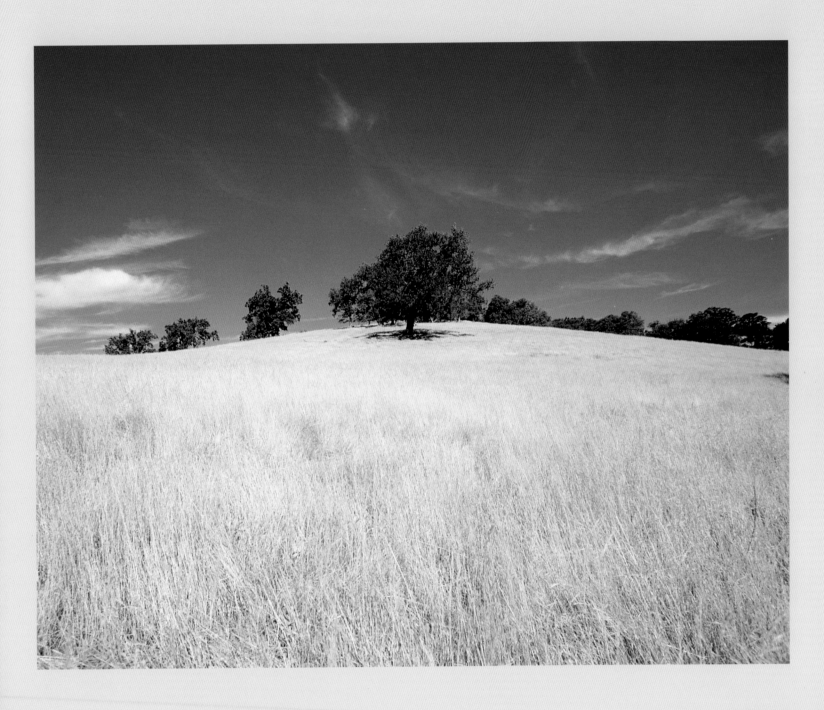

Estrella Ranch
Paso Robles, California

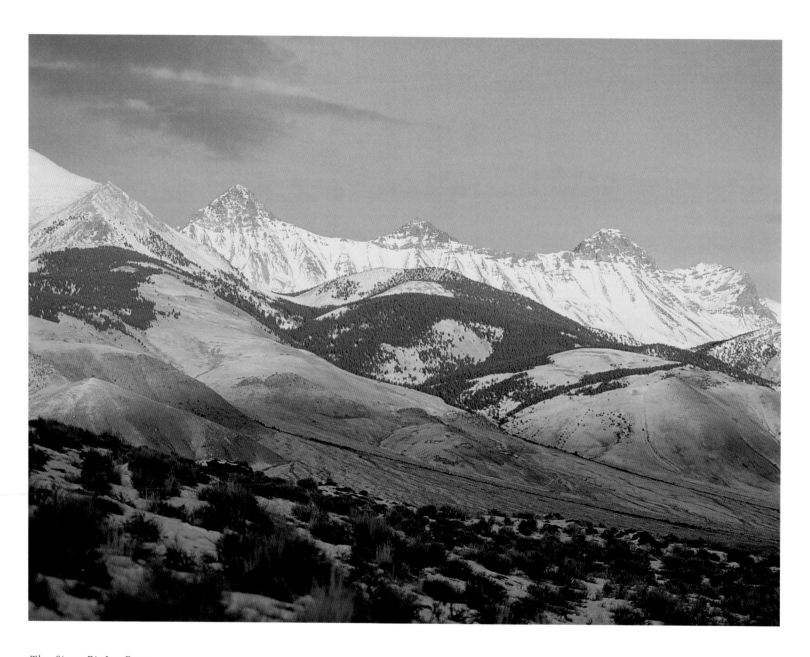

Three Sisters, Big Lost Range
Mackay, Idaho

N-Bar Land & Cattle Company
Grass Range, Montana

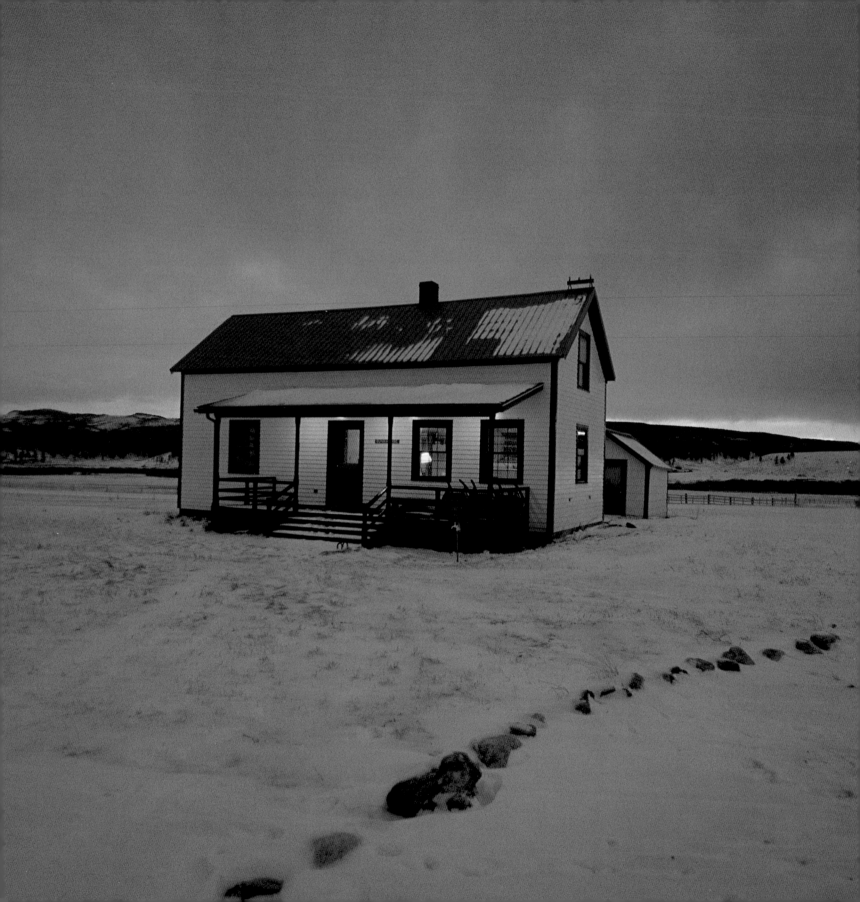

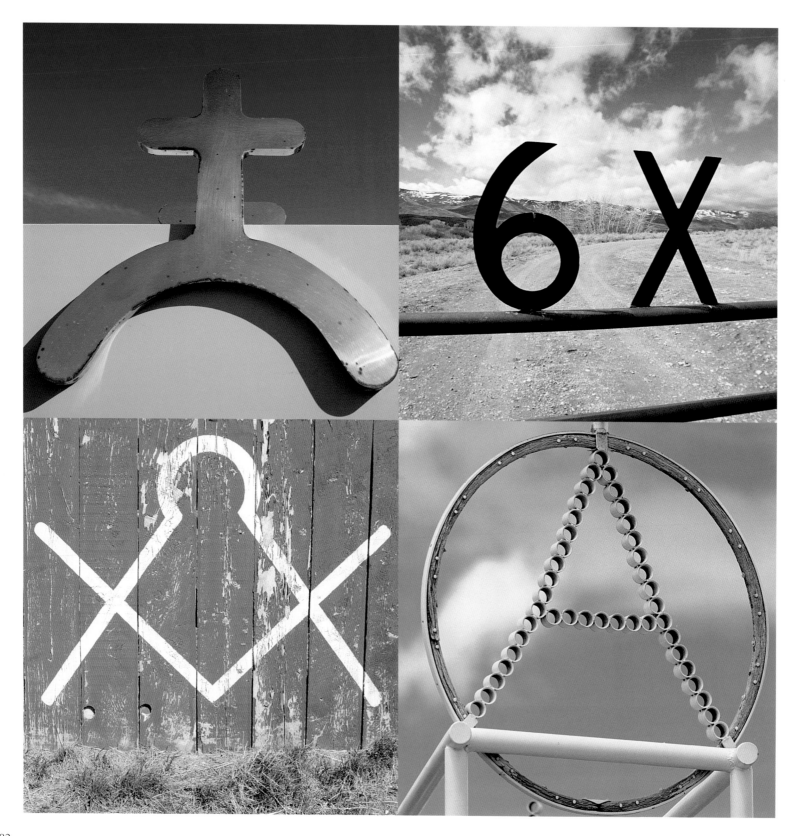

82 *Brands of the West*

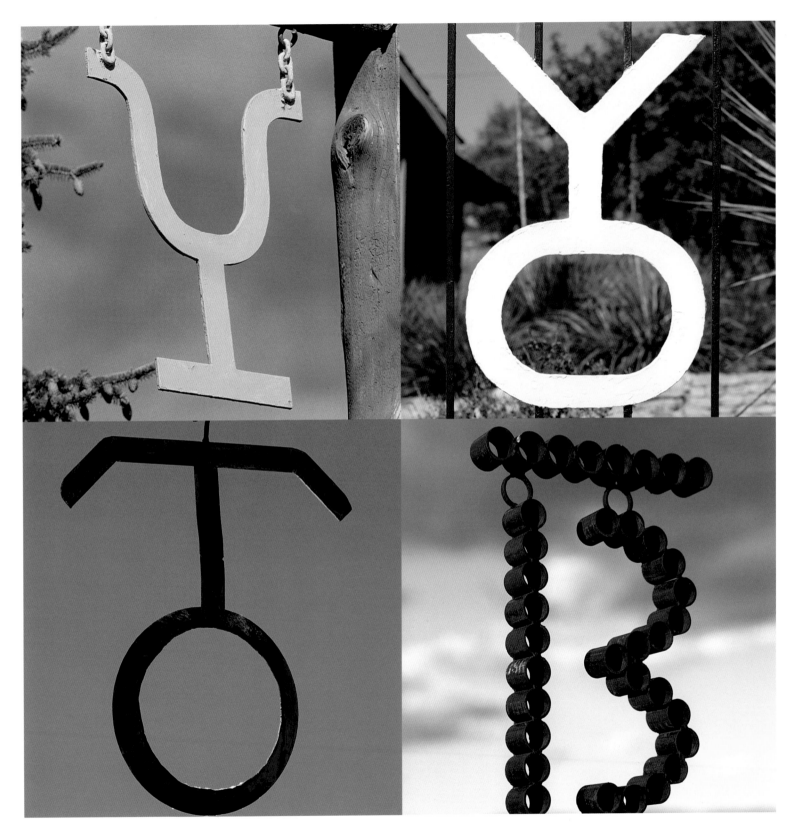

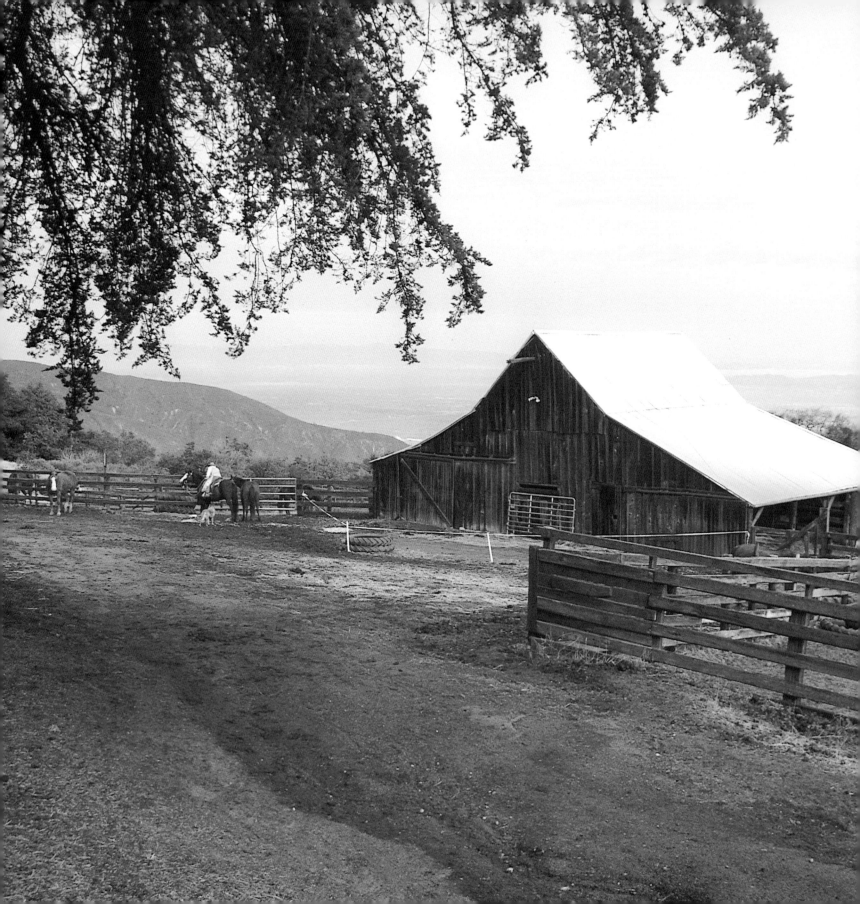

Dorrance Ranch
Salinas, California

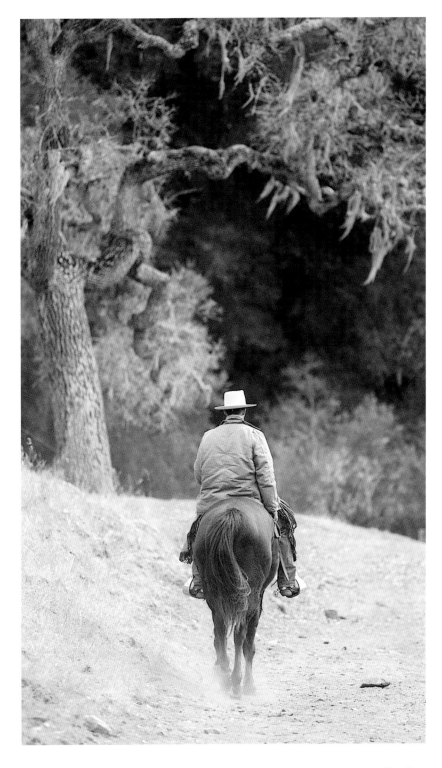

Dan Doss
Rana Creek Ranch
Carmel Valley, California

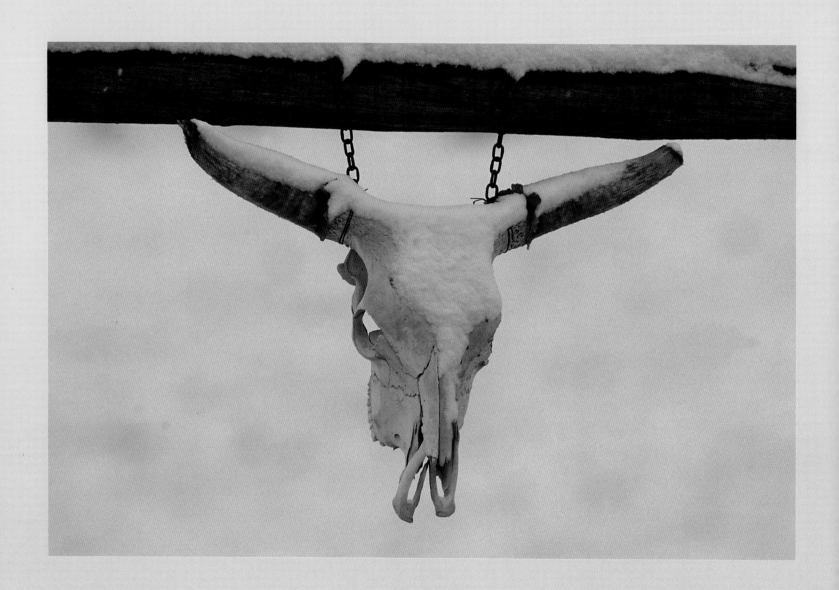

Lehman Canyon Ranch
Mackay, Idaho

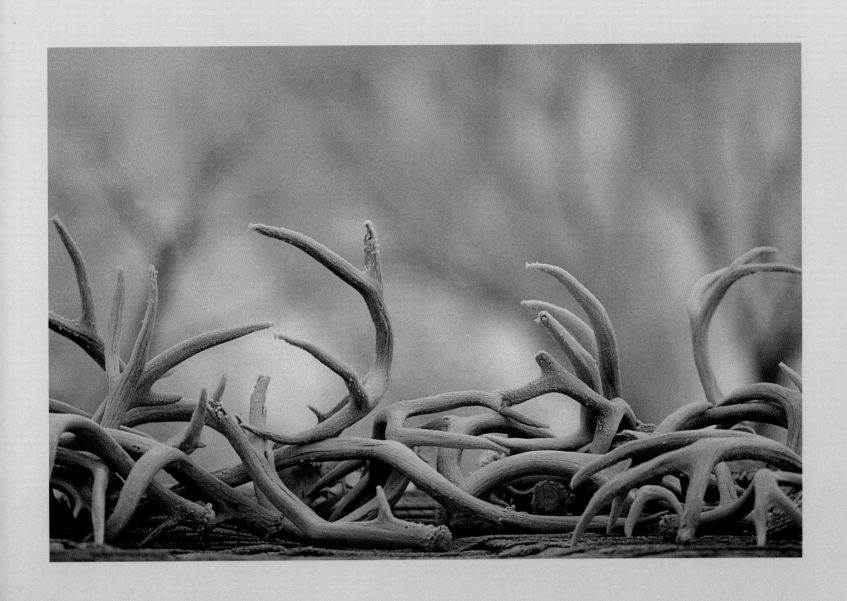

Bar 13 Ranch
Mackay, Idaho

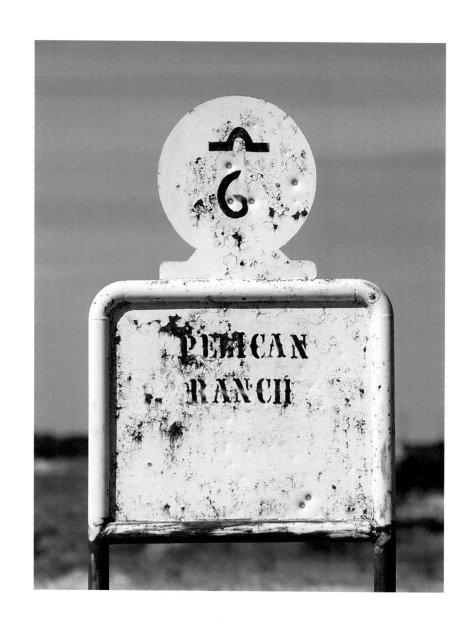

Ranch sign
Toyah, Texas

Parched landscape
Toyah, Texas

Barton Flat
Mackay, Idaho

Barton Flat
Mackay, Idaho

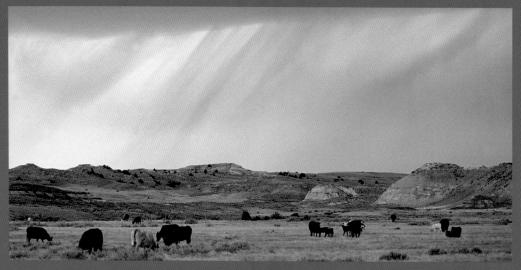

C & C Cattle Company
Montana

Remuda
YP Ranch
Tuscarora, Nevada

90

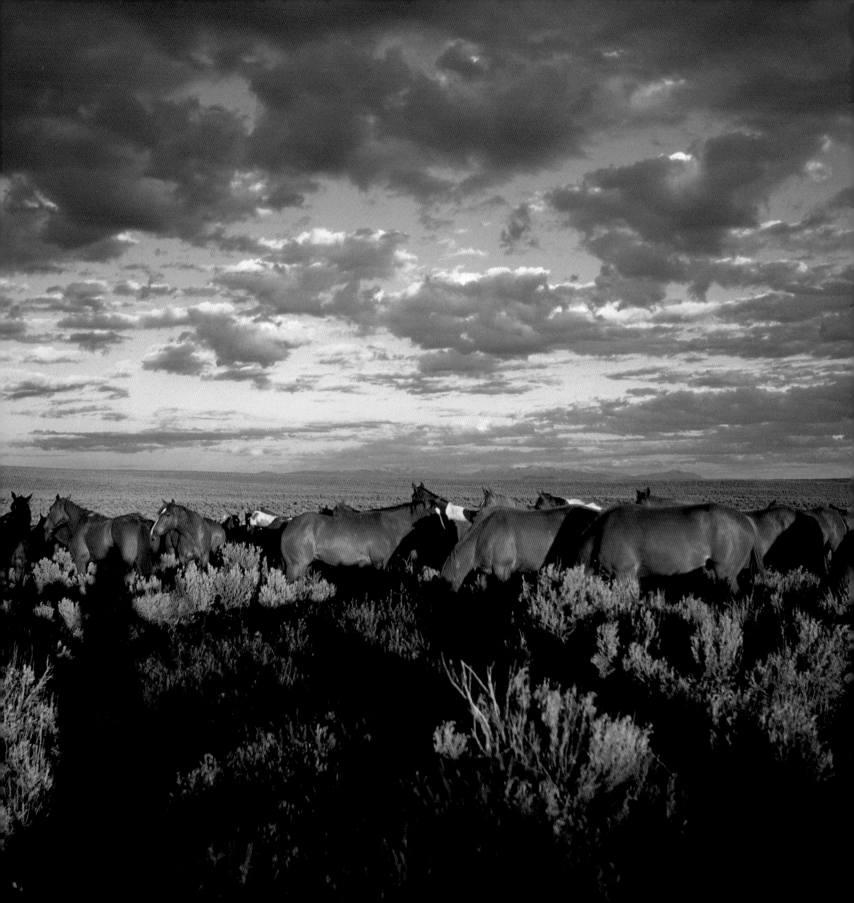

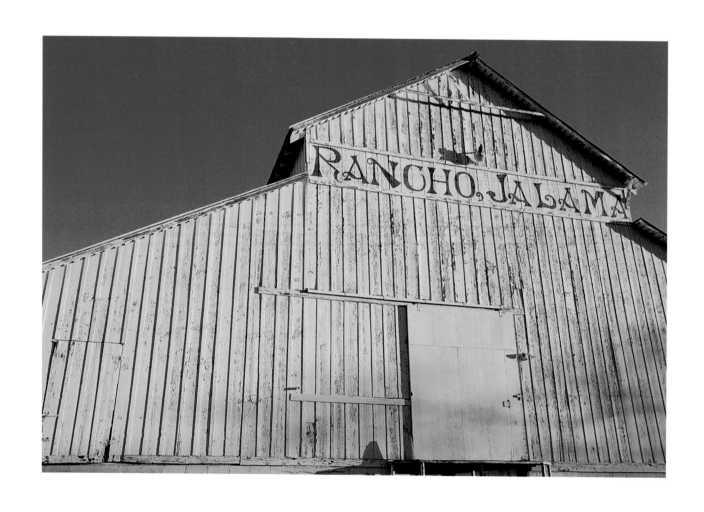

Cojo Jalama Ranch
Lompoc, California

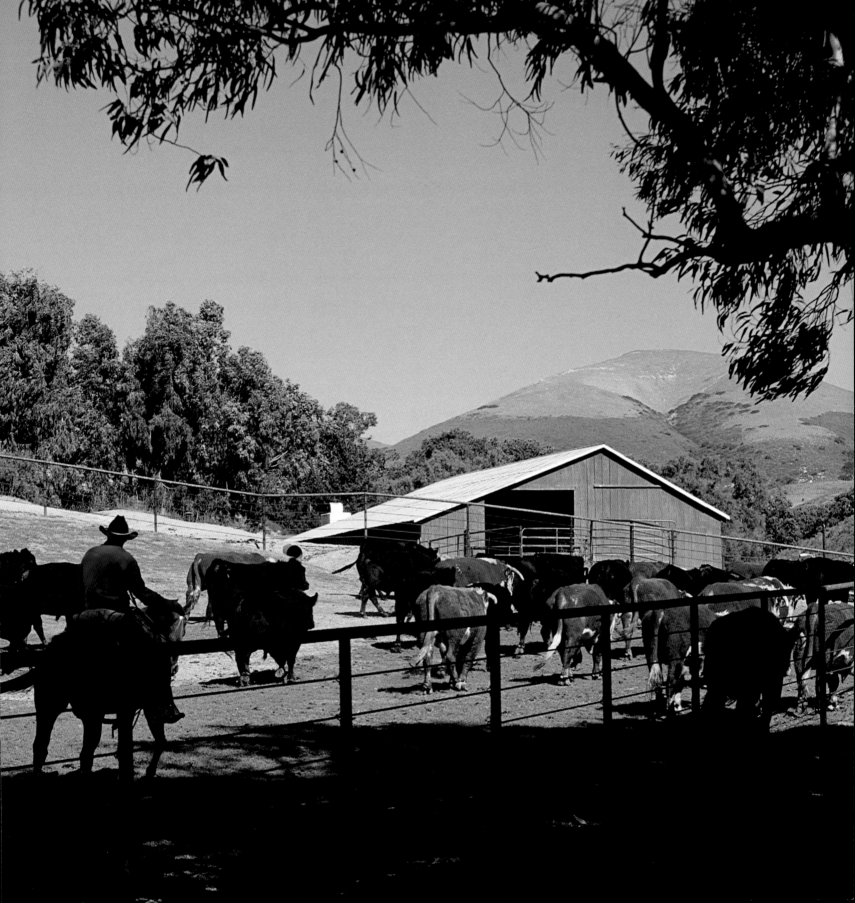

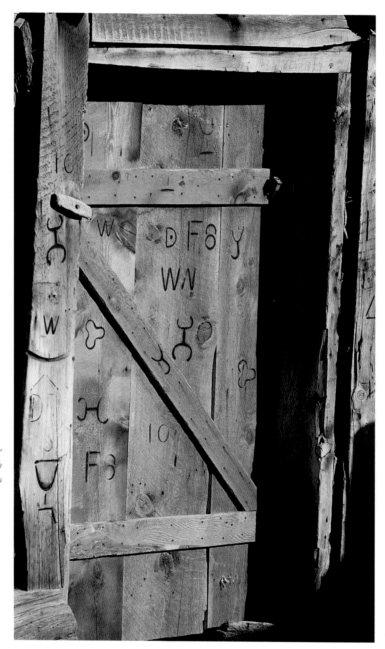

Barn door
Three Sisters Ranch
Mackay, Idaho

Store house
Three Sisters Ranch
Mackay, Idaho

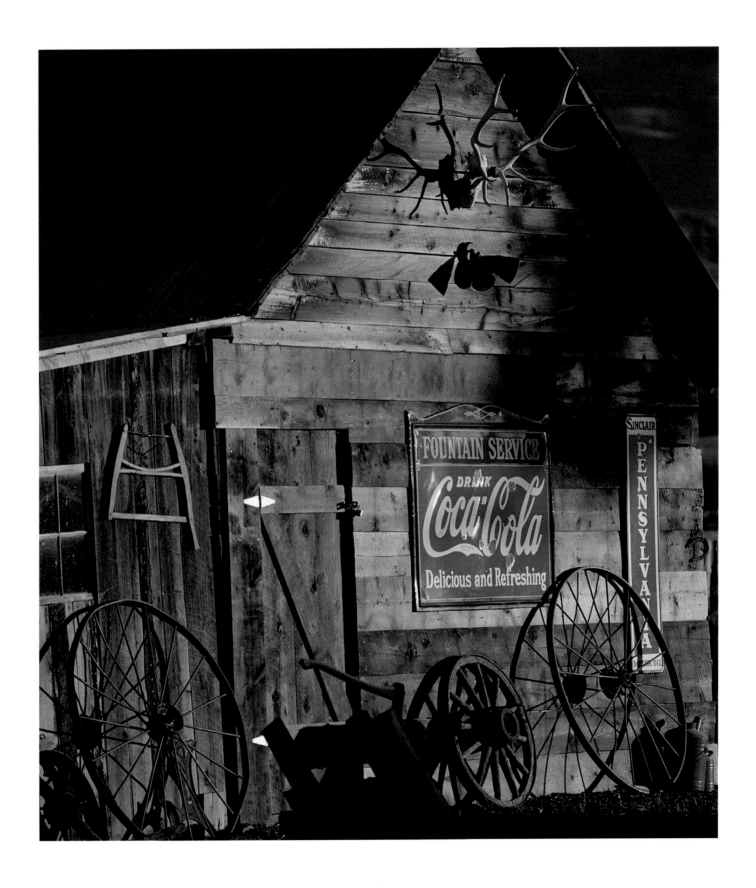

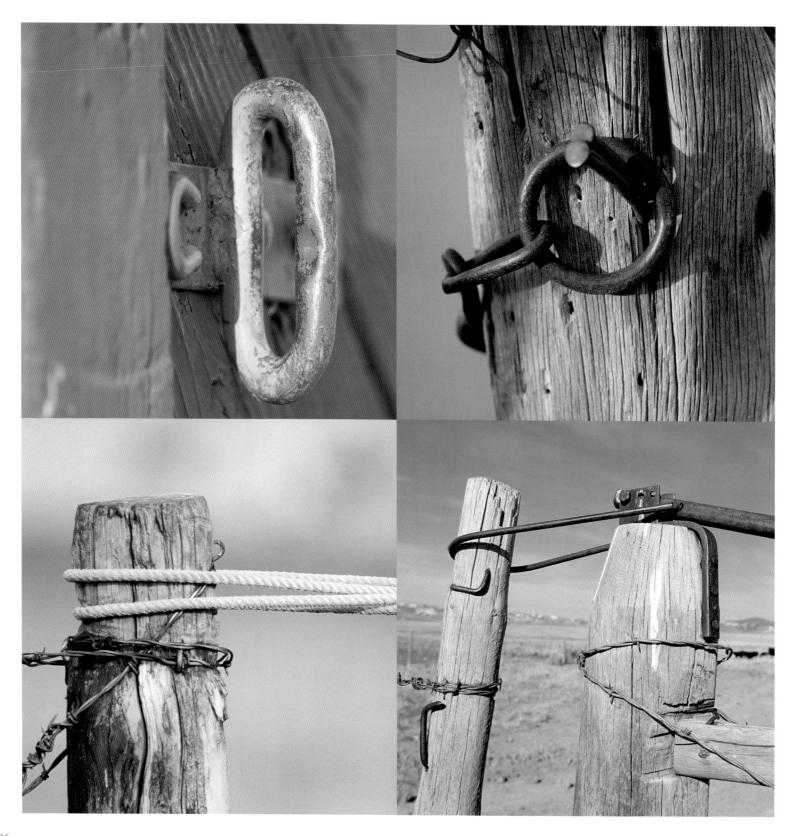

Gate latches

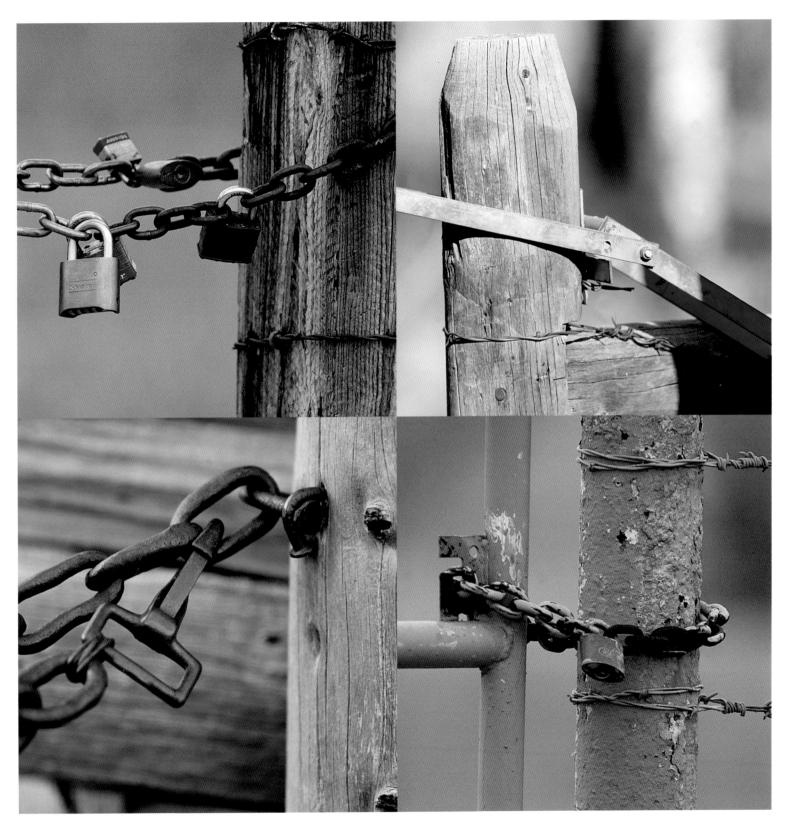

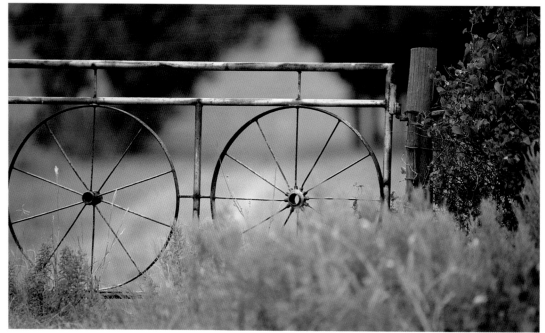

Donelle Ranch
Texas

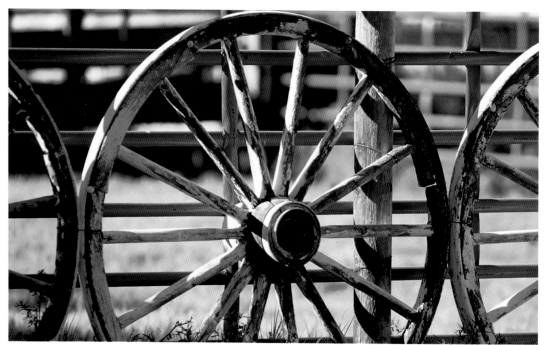

Hall Ranch
Bruneau, Idaho

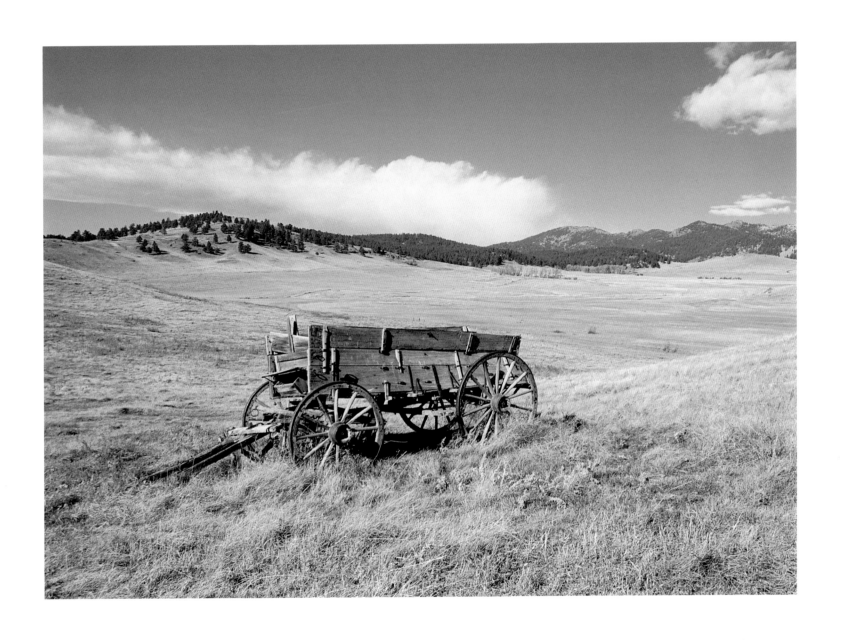

Old freight wagon
Sieben Livestock
Montana

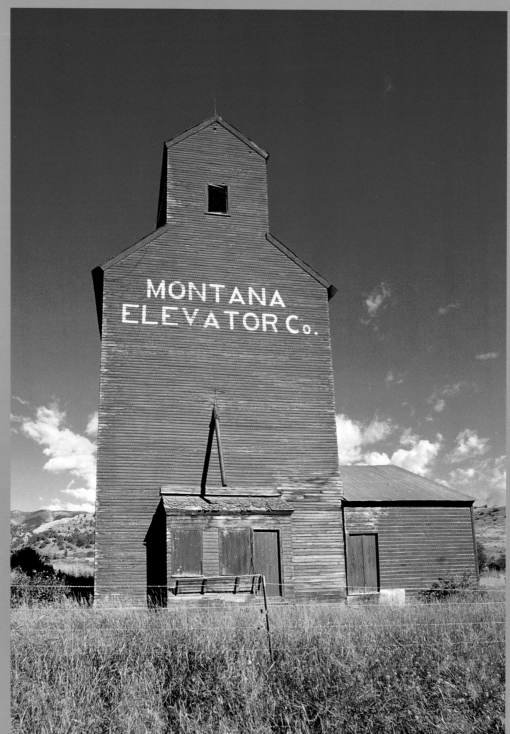

*Grain elevator
Manhattan, Montana*

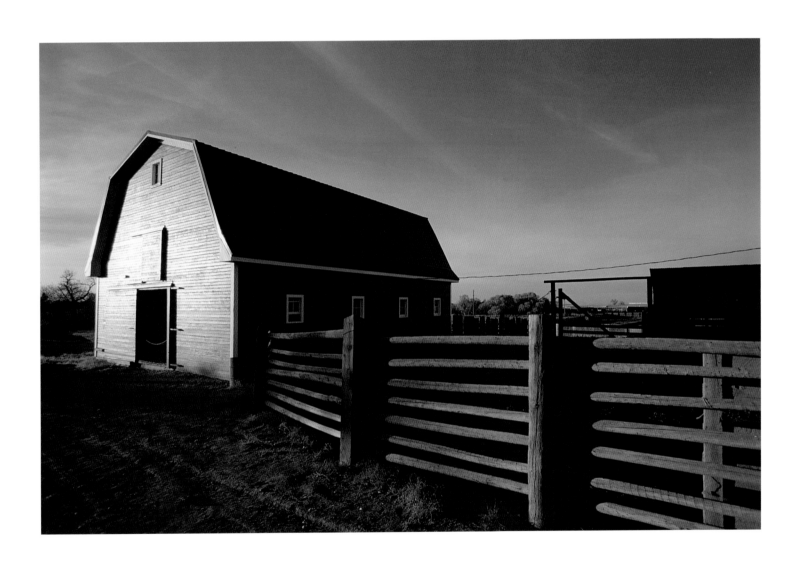

Barn
IX Ranch
Big Sandy, Montana

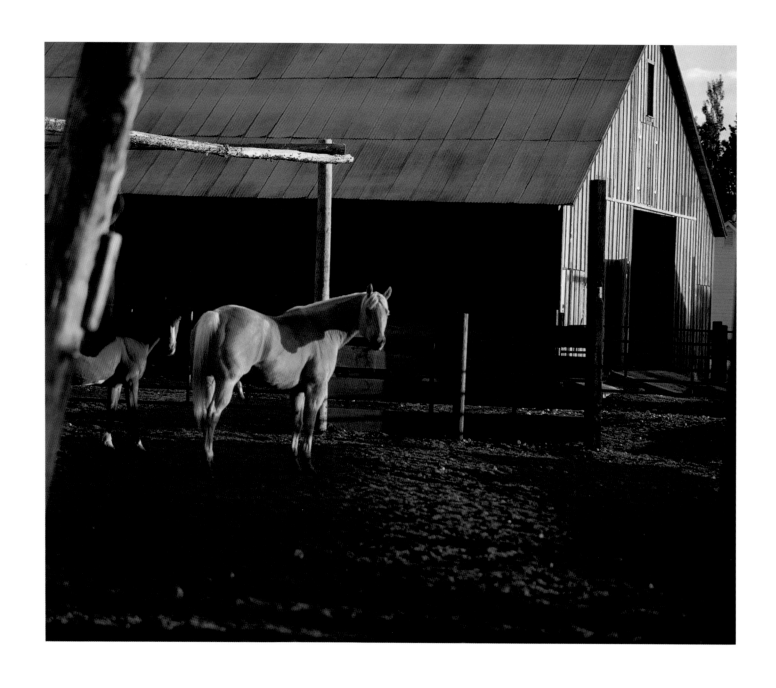

Hunewill Ranch
Bridgeport, California

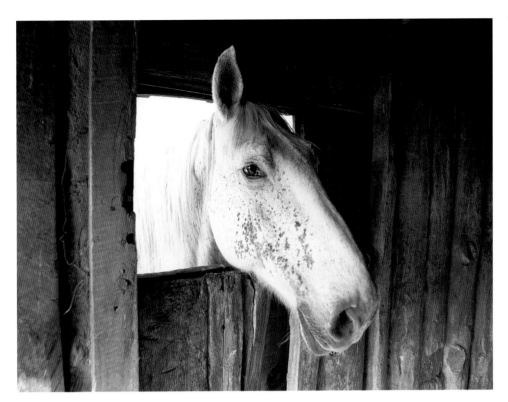

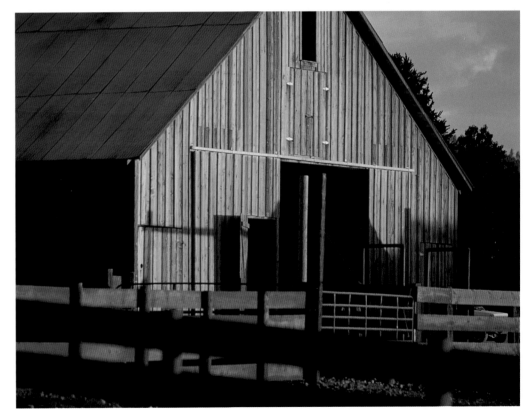

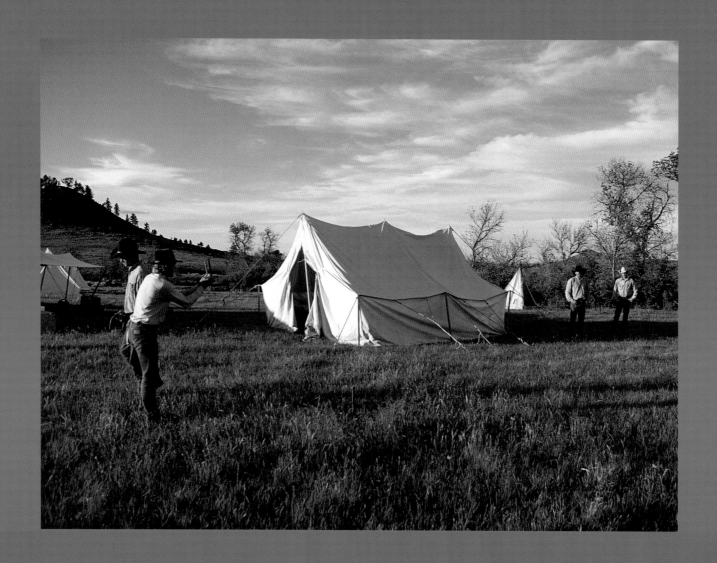

Branding camp
Padlock Ranch
Montana

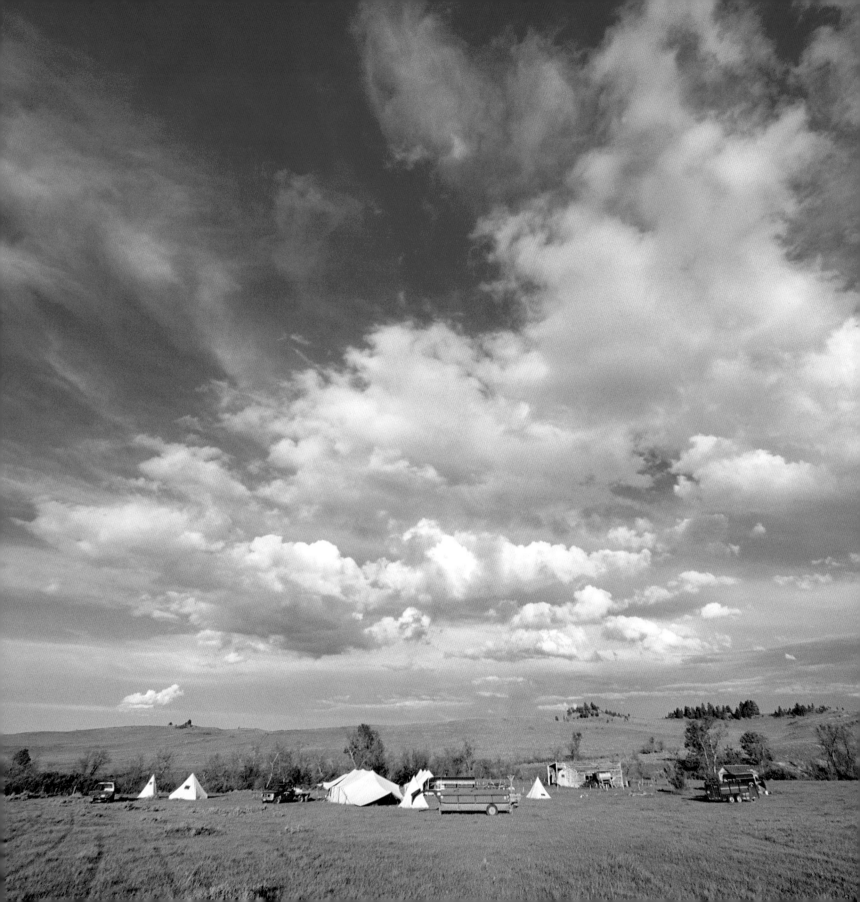

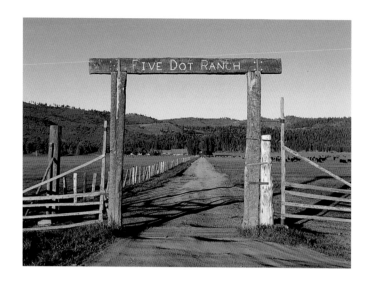
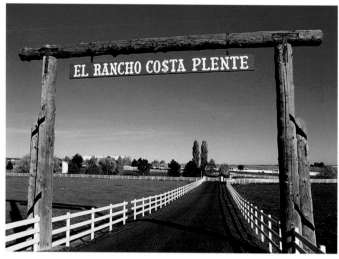
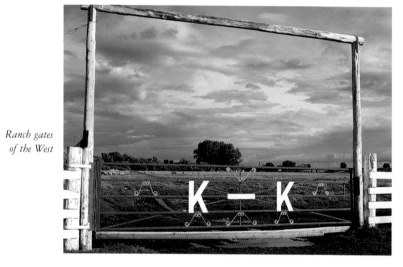
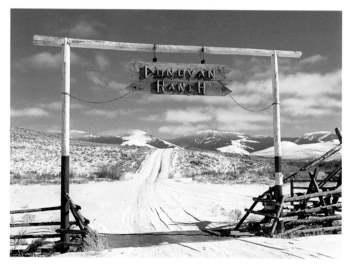

*Ranch gates
of the West*

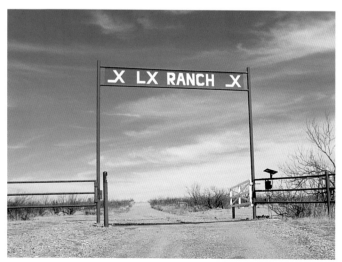
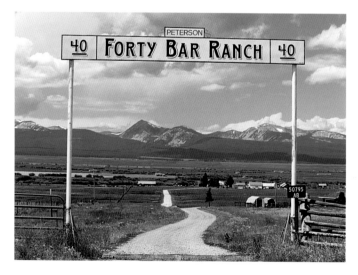

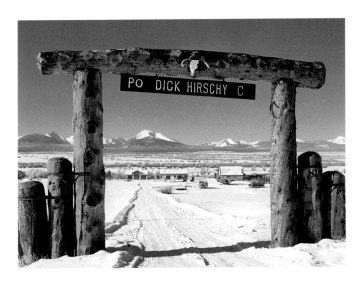

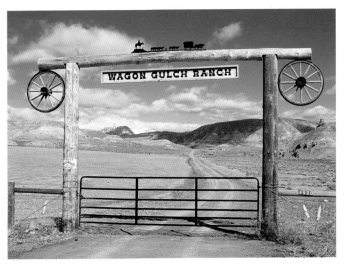

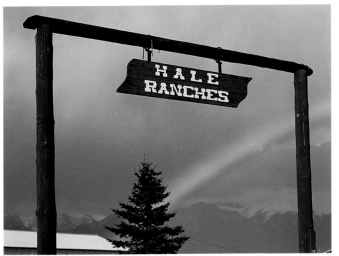

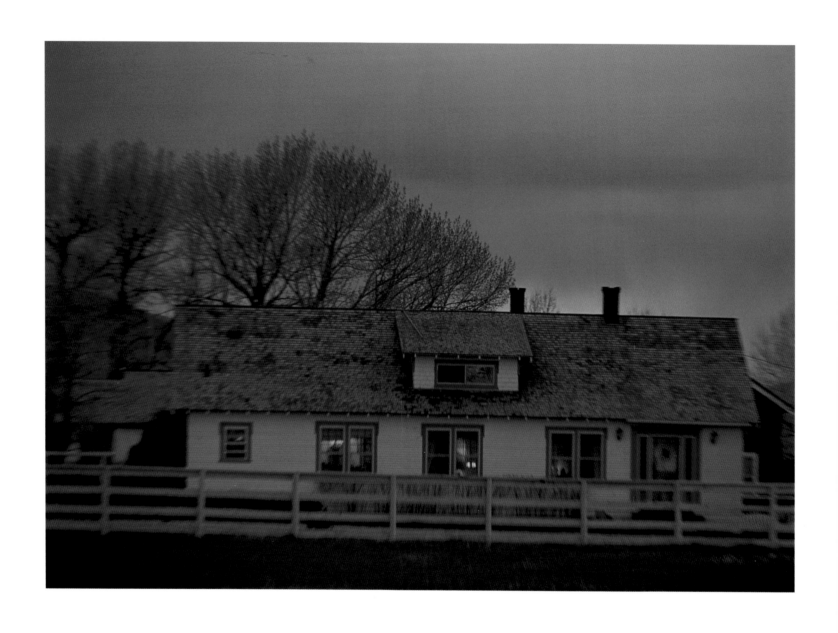

Office
Matador Ranch
Dillon, Montana

Flournoy Ranch
Likely, California

108

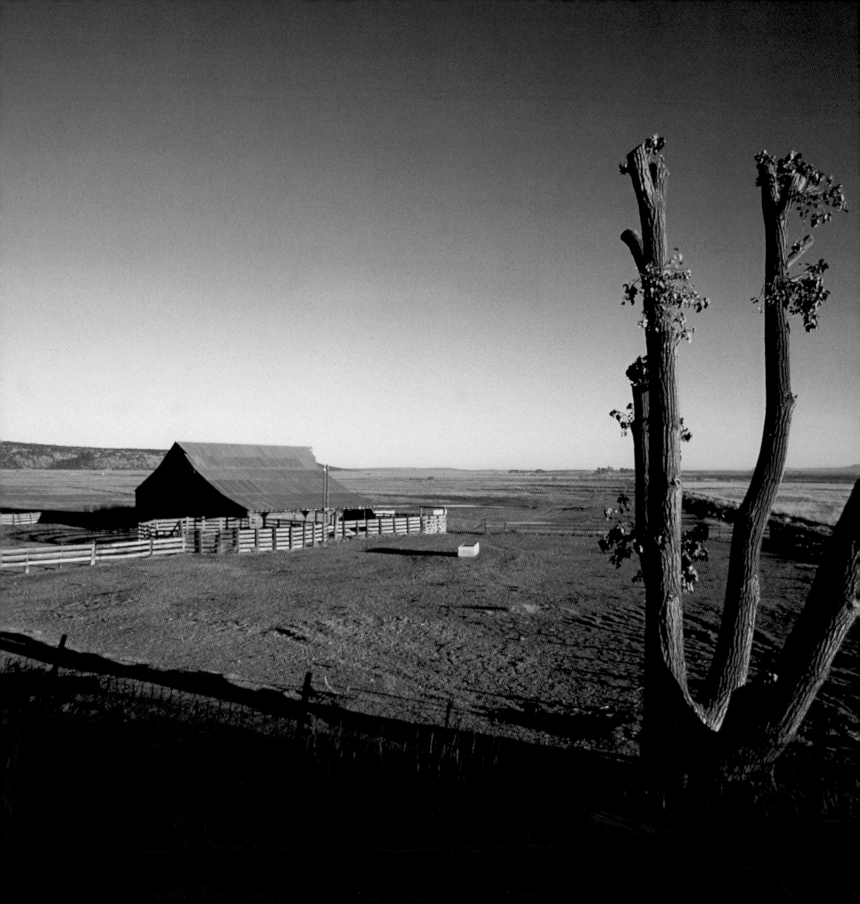

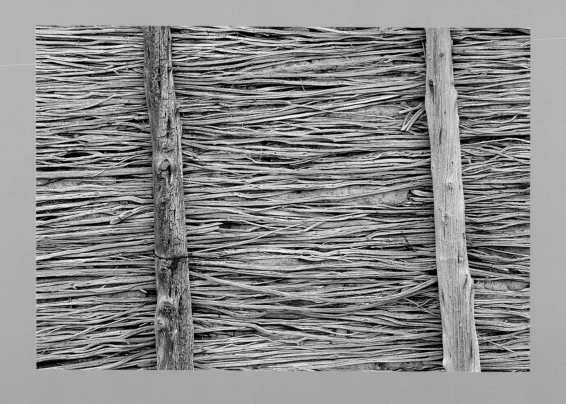

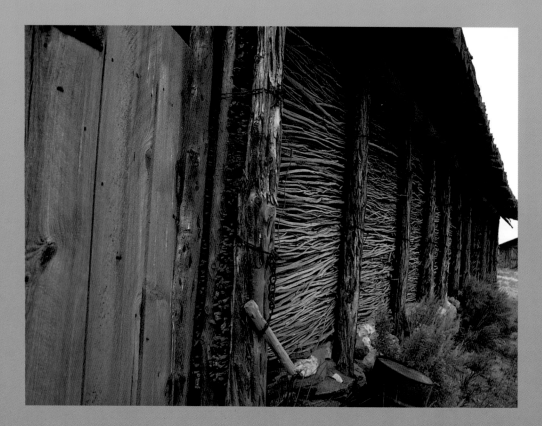

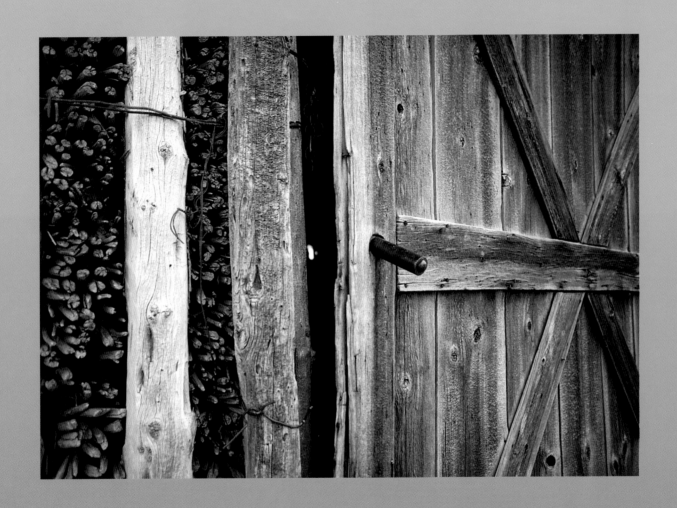

Willow barn
Brace Ranch
Bruneau, Idaho

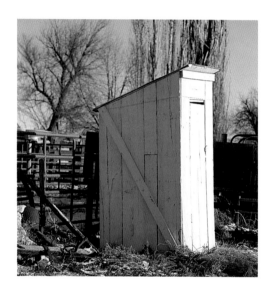 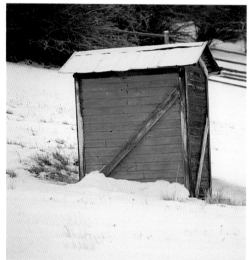 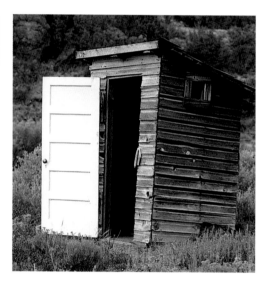

Outhouses
Idaho, Montana, Nevada

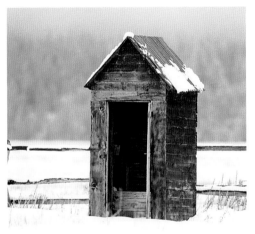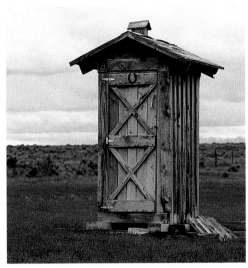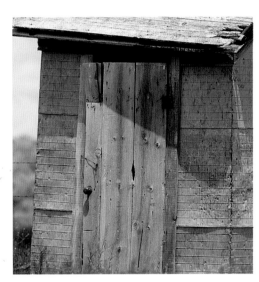

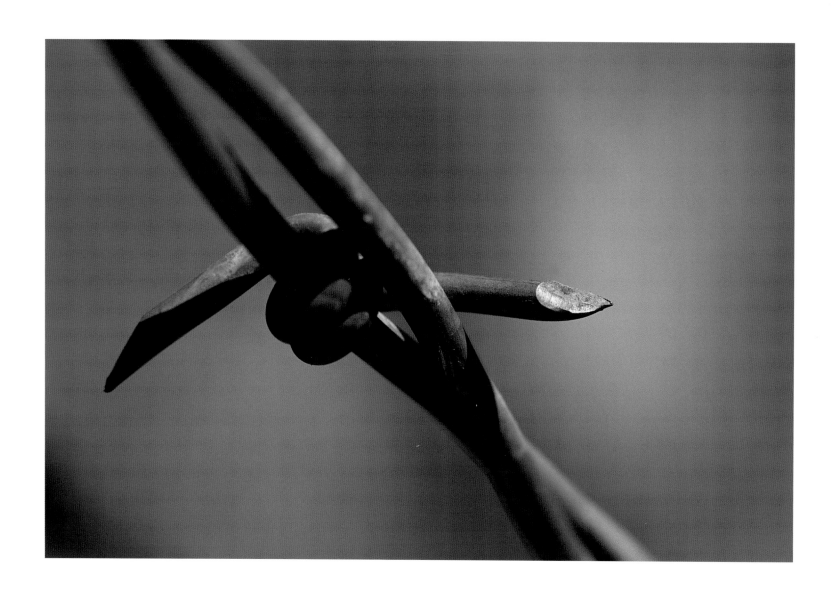

Barbed wire
Idaho

Powder River gate
Dragging Y Ranch
Horse Prairie, Montana

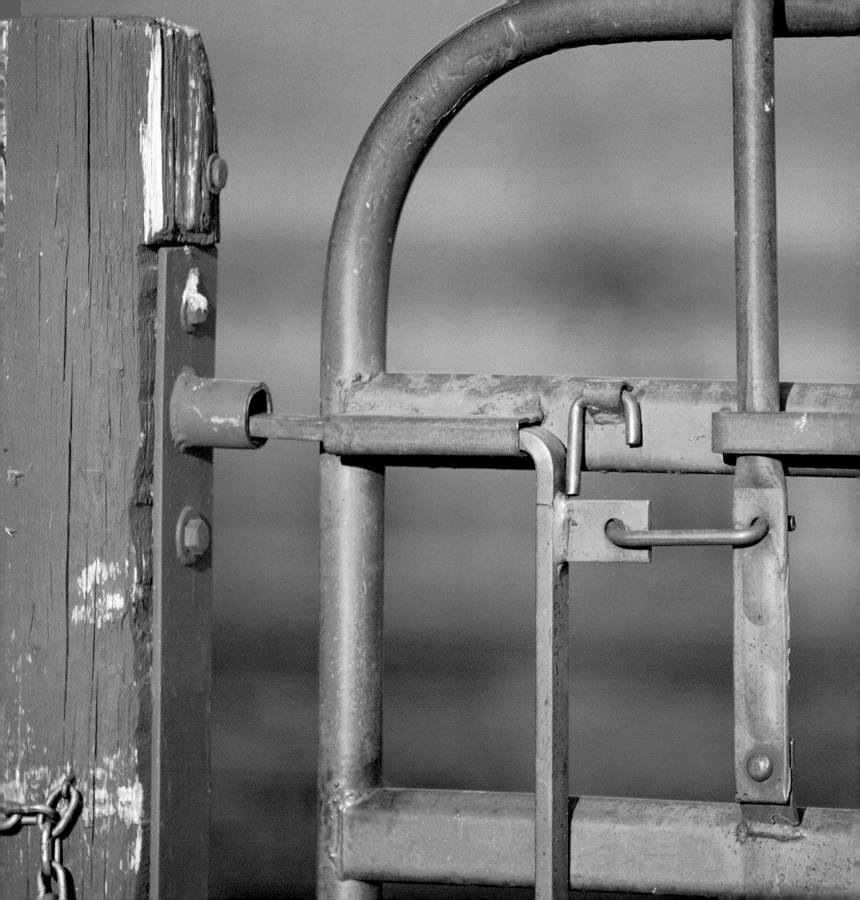

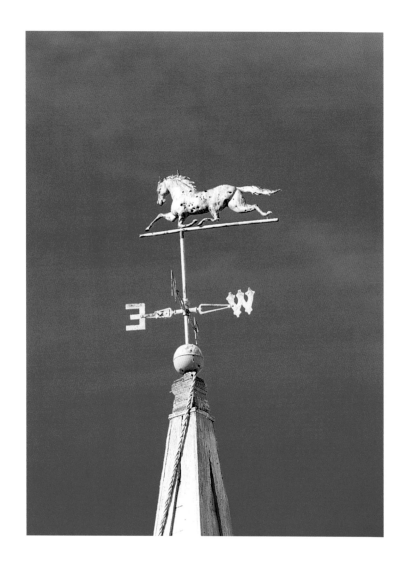

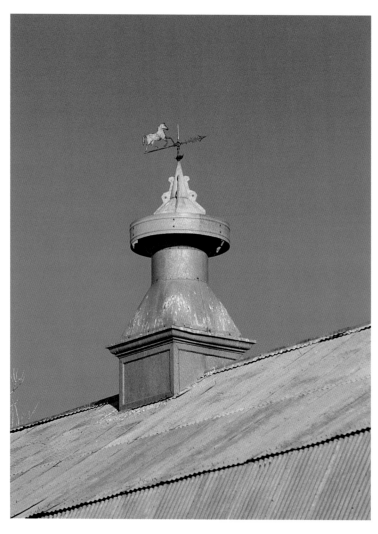

Weather vane
Belmont Park Ranch
Montana

Weather vane on cupola
Cornwell Ranch
Glasgow, Montana

116

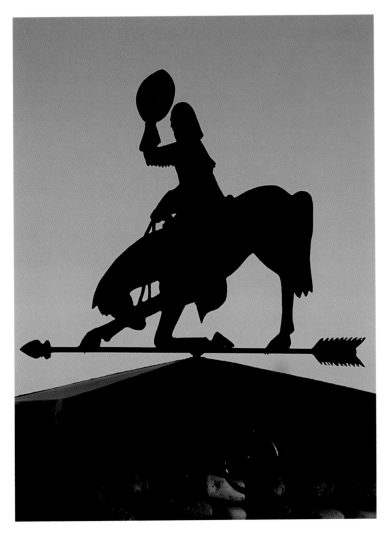

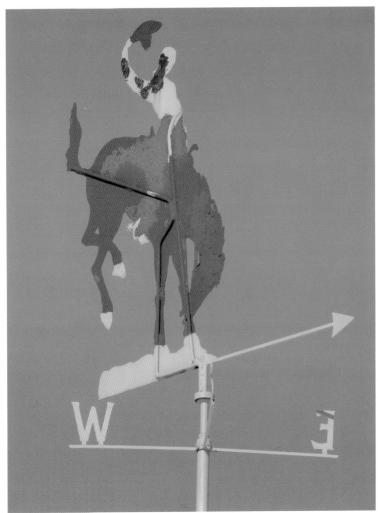

Gatepost ornament
Bellevue, Idaho

Weather vane
Sun Valley barn
Sun Valley, Idaho

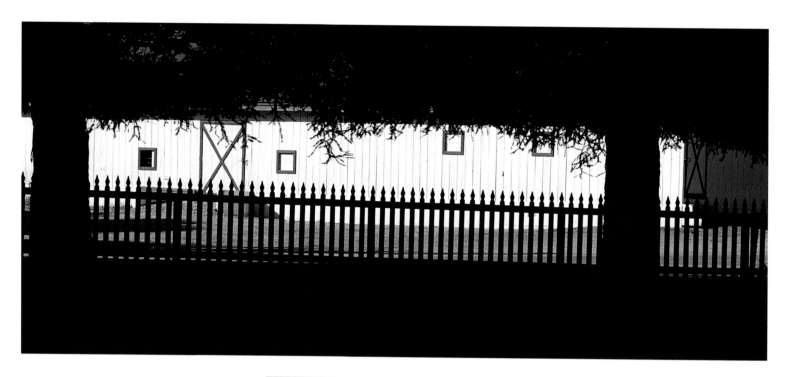

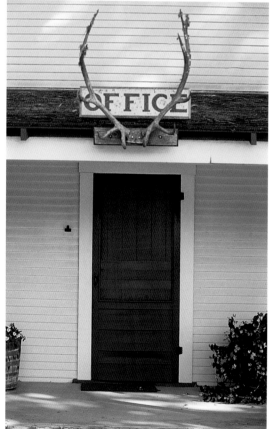

*Hearst Ranch
San Simeon, California*

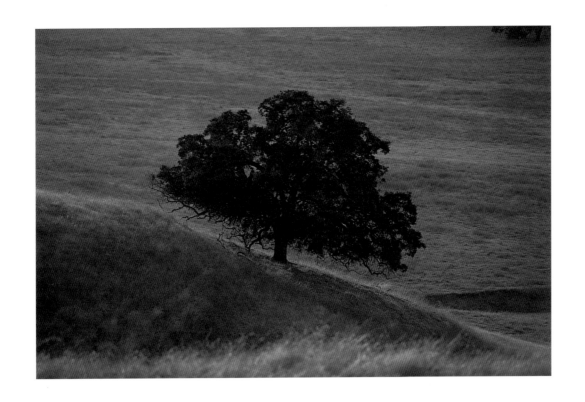

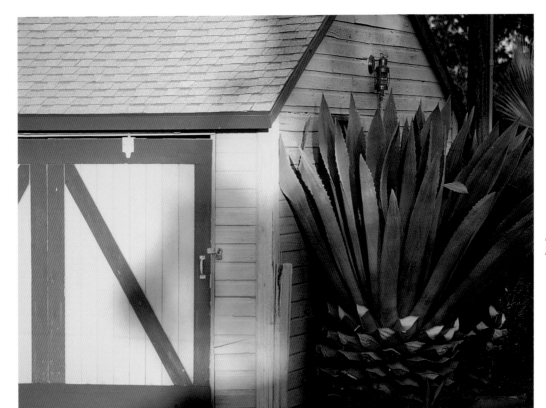

Estrella Ranch
Paso Robles, California

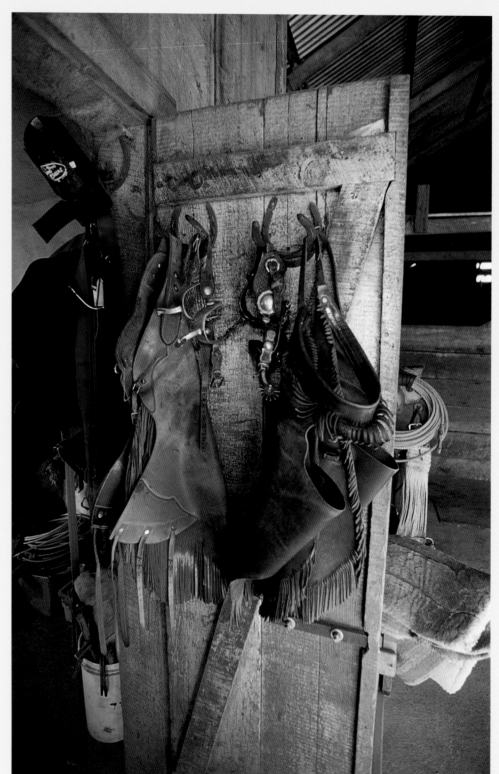

Saddle room
Dunne Ranch
Hollister, California

120

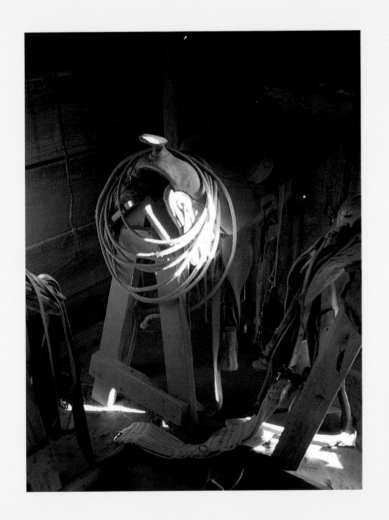

Saddle room
Pitchfork Ranch
Guthrie, Texas

Saddle room
Dunne Ranch
Hollister, California

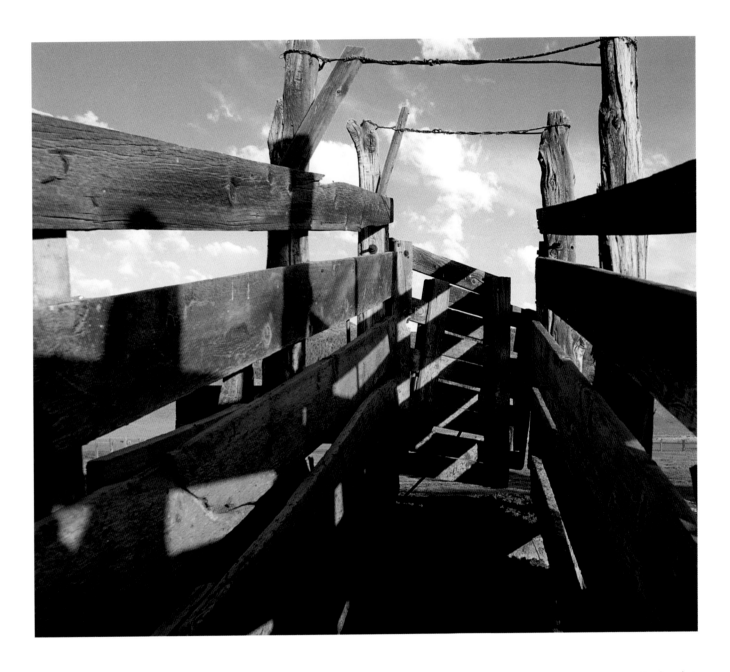

Loading chute
Jess Valley Cattle Company
Likely, California

Gate
Dragging Y Ranch
Horse Prairie, Montana

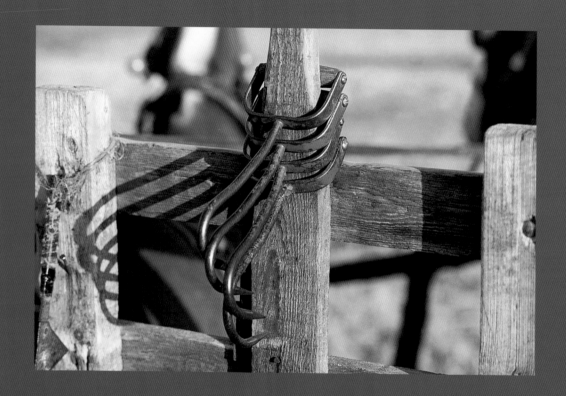

Hay hooks
Hall Ranch
Bruneau, Idaho

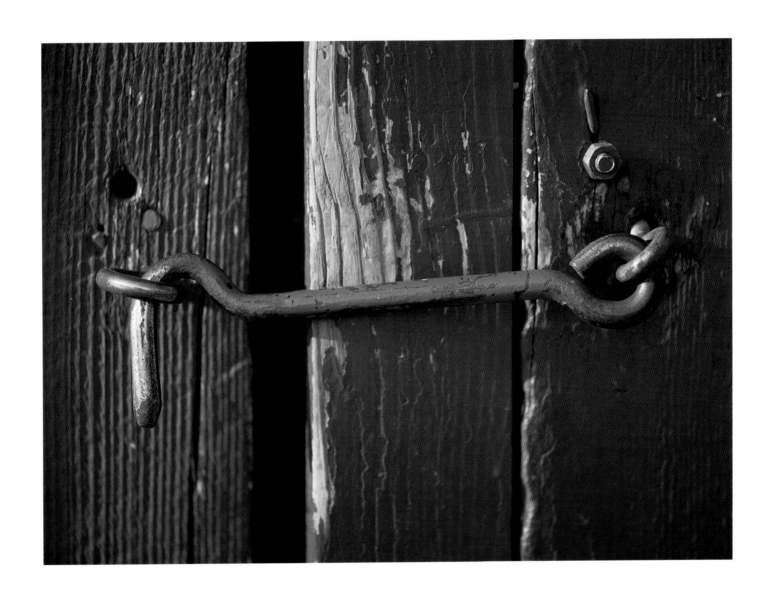

Grain shed
Hall Ranch
Bruneau, Idaho

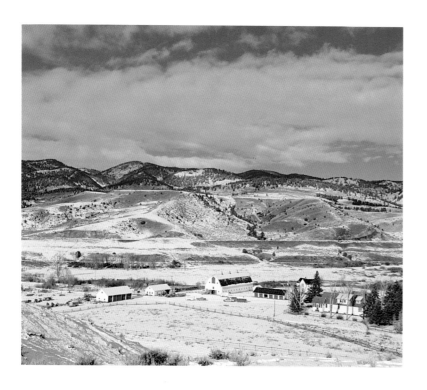

White camp
CA Ranch
Montana

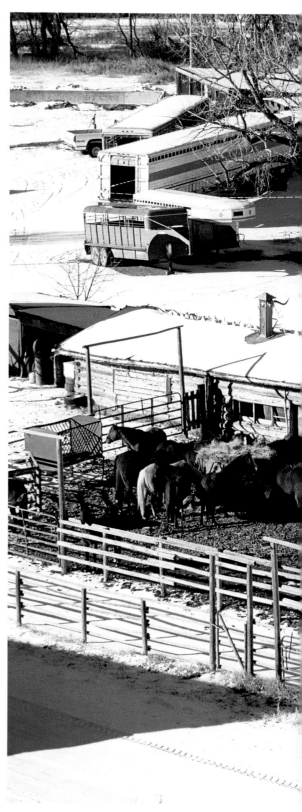

Cornwell Ranch
Glasgow, Montana

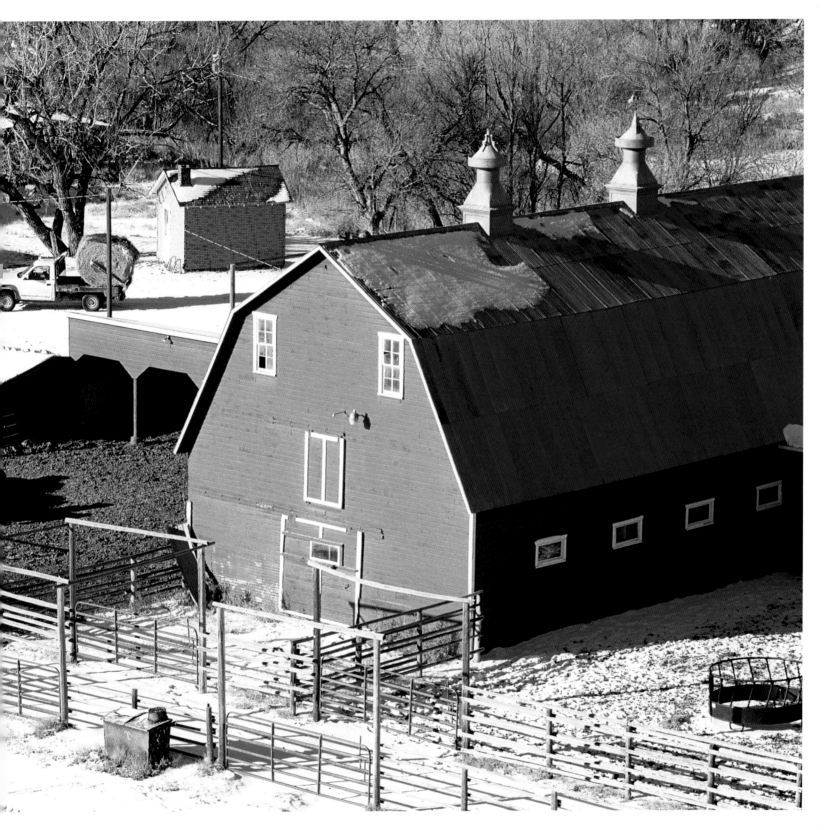

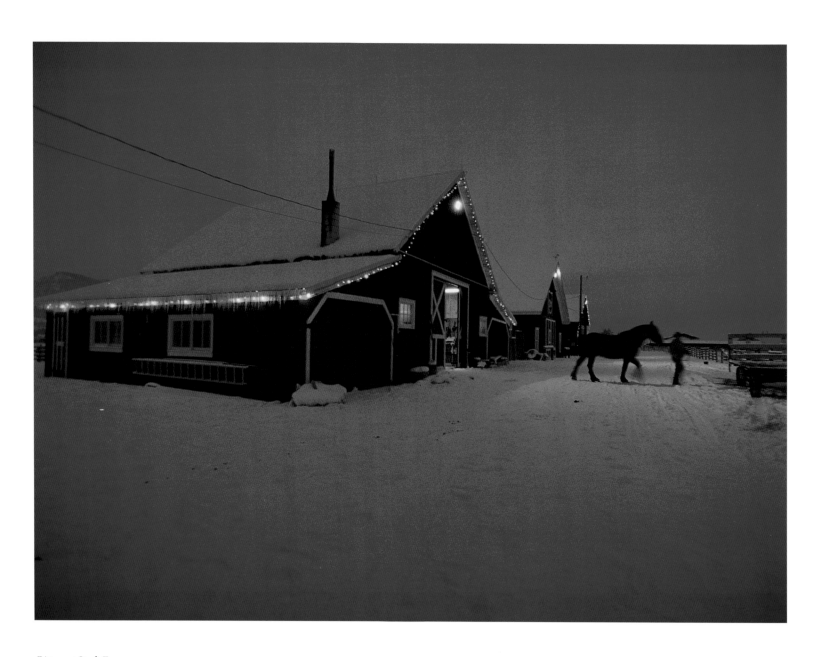

Bitterroot Stock Farm
Hamilton, Montana

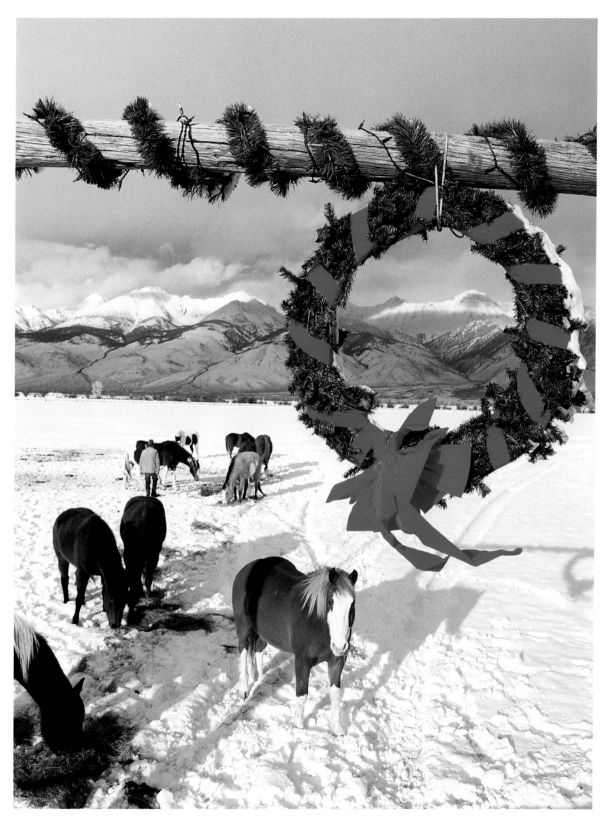

Three Sisters Ranch
Mackay, Idaho

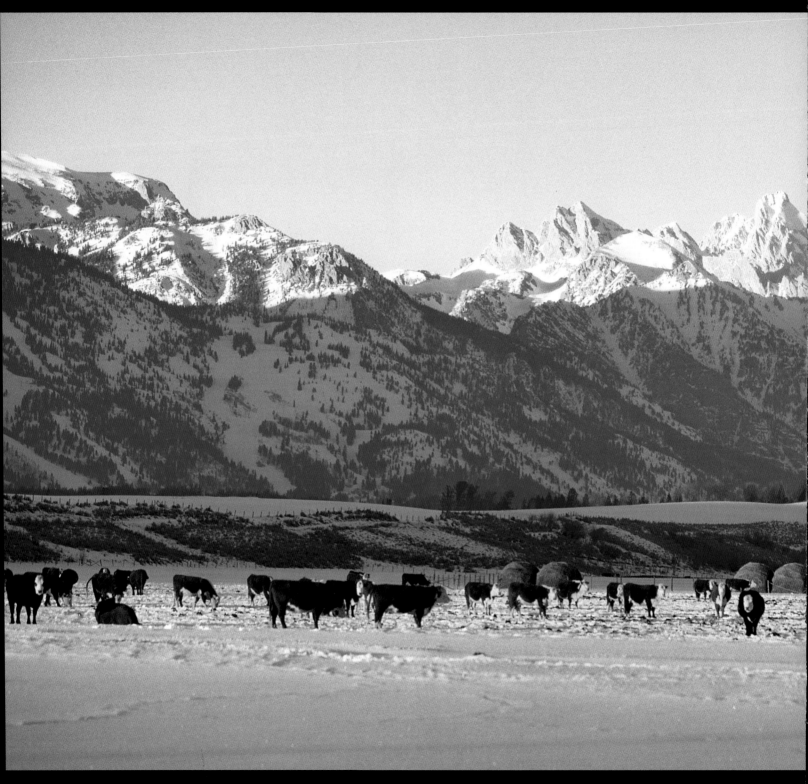

Walton Ranch
Jackson, Wyoming

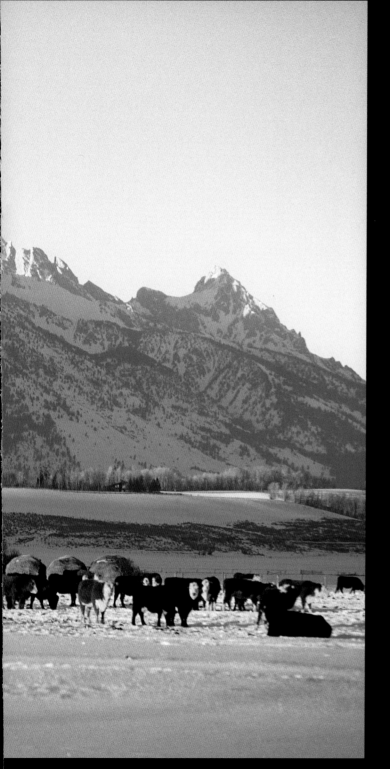

Hall Ranch
Bruneau, Idaho

Marvin Ranch
Meeker, Colorado

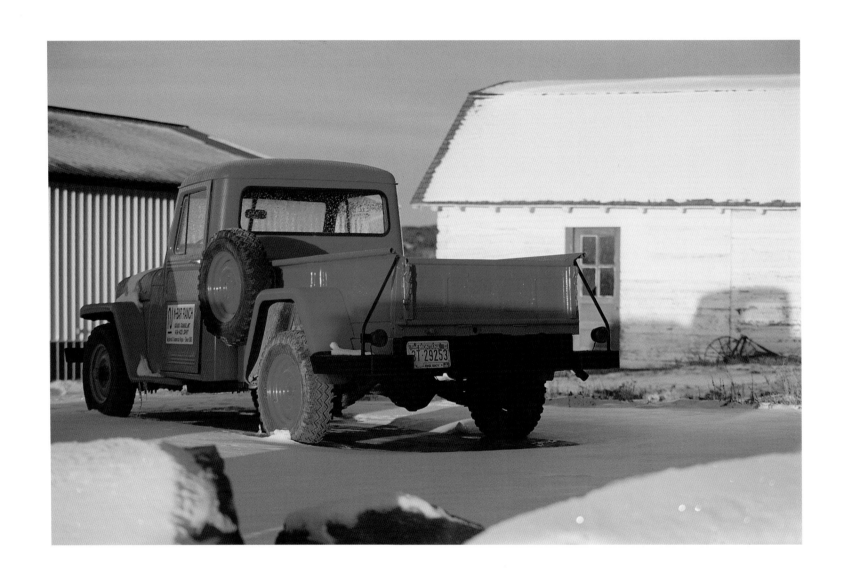

N-Bar Land & Cattle Company
Grass Range, Montana

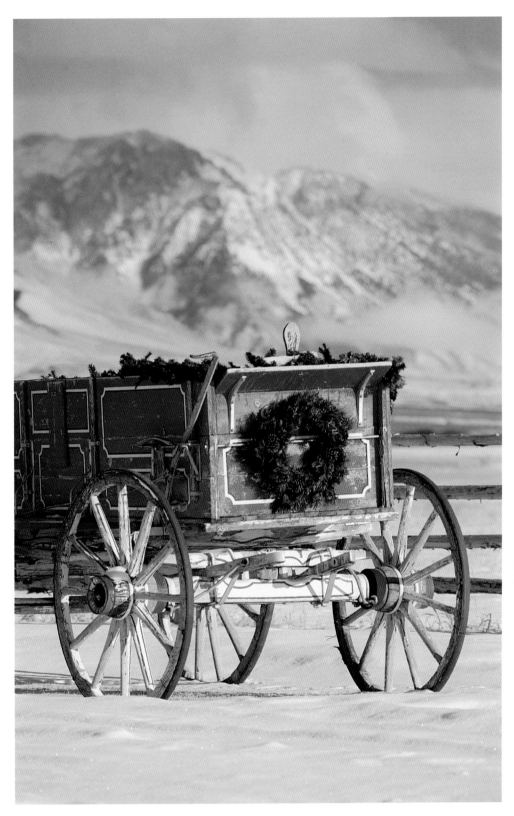

Three Sisters Ranch
Mackay, Idaho

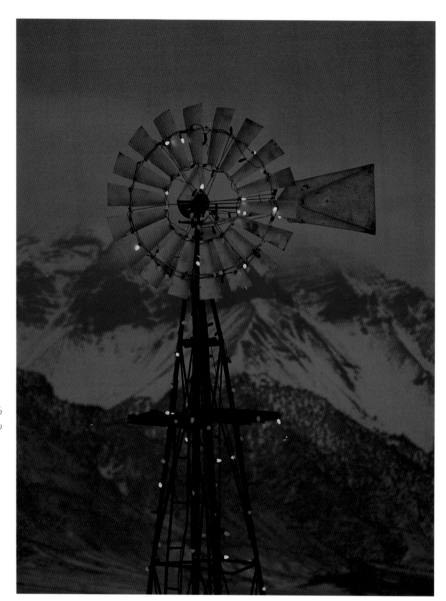

Three Sisters Ranch
Mackay, Idaho

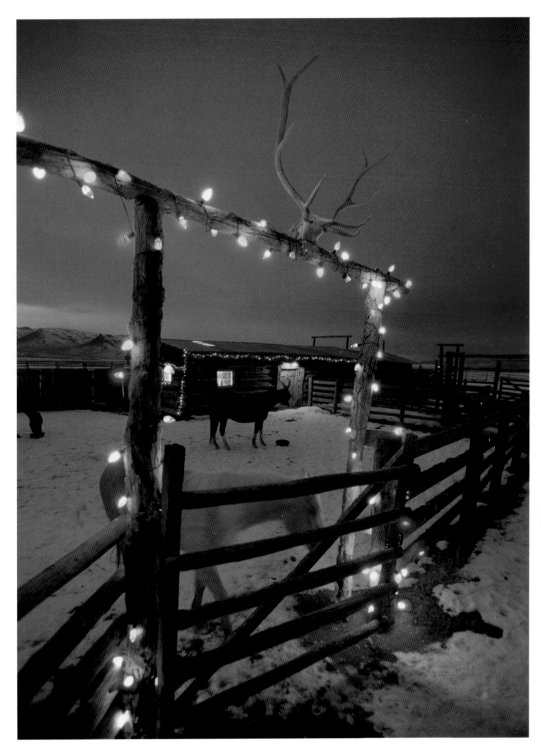

Three Sisters Ranch
Mackay, Idaho

135

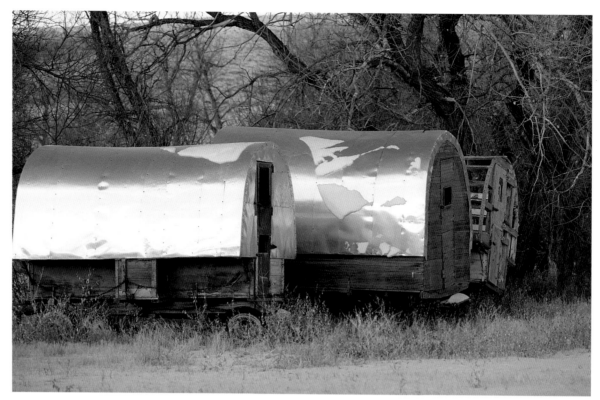

Sheep wagons
Cornwell Ranch
Glasgow, Montana

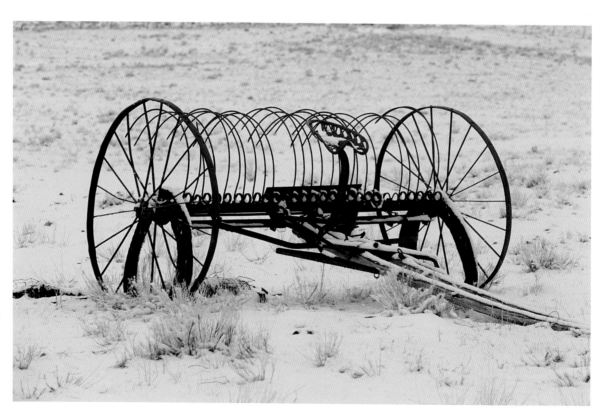

Grass rake
Quarter Circle
C Ranch
Dell, Montana

Christmas
Bitterroot Stock Farm
Hamilton, Montana

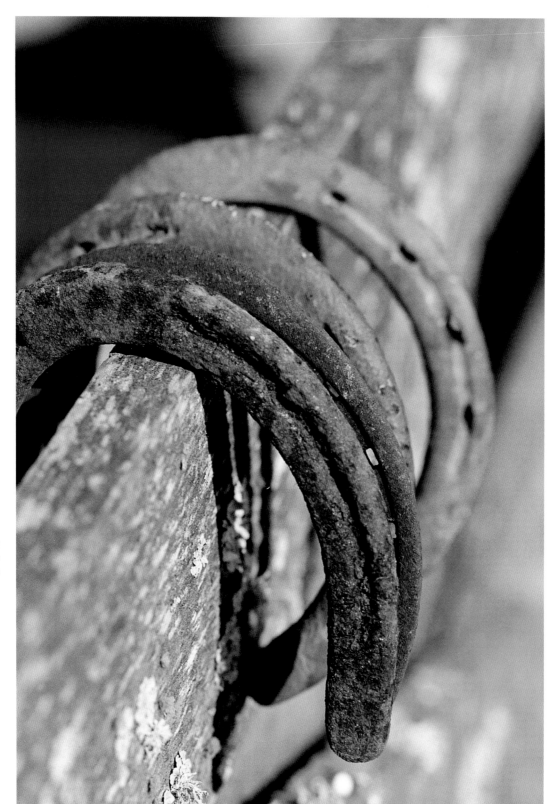

Horseshoes
Russ Ranch
Ferndale, California

Thanks to all the ranchers

who have opened their gates

for me and my camera.

David R. Stoecklein

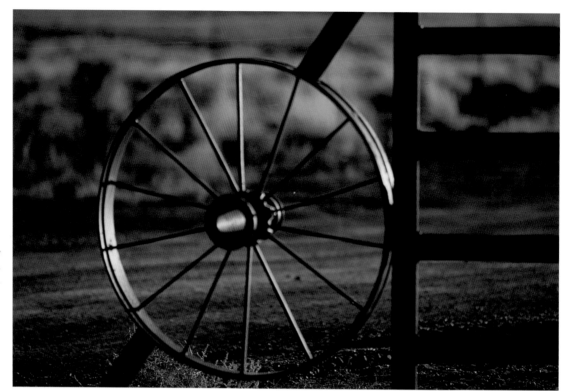

*Old wagon wheel
as gatepost
Linn, Texas*

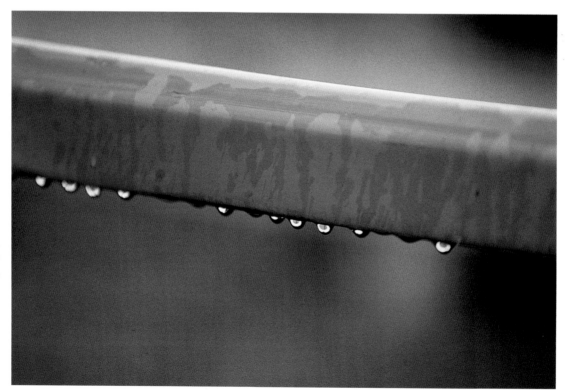

*Rain on
Powder River panel
Mackay, Idaho*

Other books by David R. Stoecklein

<table>
<tr><td>The Western Buckle</td><td>The Idaho Cowboy</td></tr>
<tr><td>The Cowboy Boot</td><td>Cowboy Gear</td></tr>
<tr><td>The Spur</td><td>The Montana Cowboy</td></tr>
<tr><td>The Performance Horse</td><td>Don't Fence Me In</td></tr>
<tr><td>Lil' Buckaroos</td><td>Cowgirls</td></tr>
<tr><td>Cow Dogs</td><td>The Texas Cowboys</td></tr>
<tr><td>Spirit of the West</td><td>The Western Horse</td></tr>
<tr><td>The American Paint Horse</td><td>Sun Valley Images</td></tr>
<tr><td>The California Cowboy</td><td>Sun Valley Signatures I, II, III</td></tr>
</table>

The Stoecklein Gallery

Any of the images from this book can be ordered as a custom print in a variety of different sizes.
Please contact the gallery at 208-726-5191 or visit us online at www.stoeckleinphotography.com if you have any
questions or would like to place an order. If you ever get the chance to spend time in the
Sun Valley area, be sure to visit our gallery just north of Ketchum on Highway 75. In addition to a
selection of incredible framed fine art prints of Sun Valley and the surrounding area, we offer an
amazing collection of western memorabilia, prints, books, calendars, and cards.

Stoecklein Photography and Publishing, LLC
10th Street Center, Suite A1
PO Box 856
Ketchum, ID 83340
208.726.5191 tel
208.726.9752 fax
www.stoeckleinphotography.com

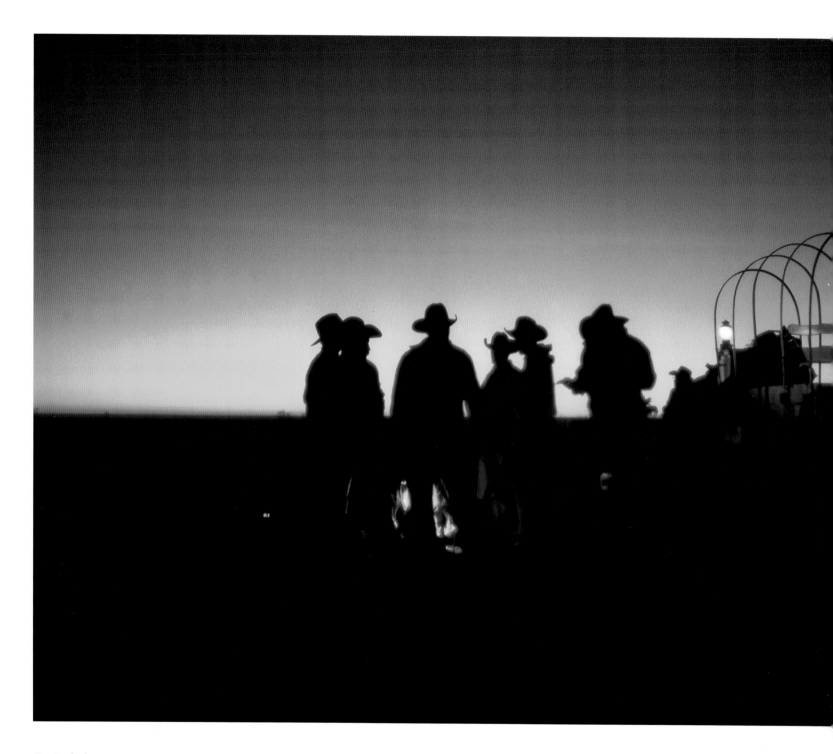

Sunrise chuck wagon
Eppenaur Ranch
Toyah, Texas

Vaya con Dios